# Elder Grace

A BULFINCH PRESS BOOK
LITTLE, BROWN AND COMPANY
BOSTON   NEW YORK   LONDON

# *Elder Grace*

## THE NOBILITY OF AGING

## CHESTER HIGGINS JR.

*Foreword by Maya Angelou*

TEXT BY CHESTER HIGGINS JR. AND BETSY KISSAM

Also by Chester Higgins Jr.:

*Black Woman (with Harold McDougall)*

*Drums of Life: A Photographic Essay on the Black Man in America (with Orde Coombs)*

*Some Time Ago: A Historical Portrait of Black Americans, 1850–1950 (with Orde Coombs)*

*Feeling the Spirit: Searching the World for the People of Africa*

First Edition

Library of Congress Cataloging-in-Publication Data
Higgins, Chester.
    Elder grace : the nobility of aging / Chester  Higgins Jr. ; text
  by Chester Higgins Jr. and Betsy Kissam.—1st ed.
      p. cm.
    ISBN 0-8212-2687-8
      1. Afro-American aged—Portraits—Exhibitions. 2. Aged—United
States—Portraits—Exhibitions. 3. Afro-American aged—Conduct
of life—Exhibitions. 4. Aging—Quotations, maxims, etc. 5. Afro-
American aged—Biography. I. Kissam, Betsy.
II. Title.

E185.86 H653 2000
305.26'0973—dc21
                                                    00-035669

Bulfinch Press is an imprint and trademark of Little, Brown and
Company (Inc.)
Designed by Jean Wilcox
Printed and bound by Eurografica, Vicenza
PRINTED IN ITALY

# CONTENTS

Foreword
by Maya Angelou

6

Acknowledgments

9

Introduction

10

IN THEIR HEARTS

12

THE GENERATION OF US

36

DIVINE WORKS IN PROGRESS

60

UNTIL SUCH TIME

82

Epilogue

102

Biographies

103

# Foreword
## by Maya Angelou

The Grace of these Elders has been gravely earned and sorely paid for.

The winds blew
The storms raged
And they stood like pillars.

> Elder Grace

The rains came
And the snows fell
And they stood like giants.

> Elder Grace

They live time with such courage
That they allow the traceries of the years
To adorn their faces.

> Elder Grace

They recall the years with familiar stories.
    "That was the year when Buddy
    joined up with the army
    and we won that war."
and
    "That was the year when
    if bad health had slapped me in the face,
    I would not have recognized it."

These Elders of Grace show that poverty need not grind the spirit into dust, nor should prosperity separate the fortunate from the needy.

Their resolute faces attest to the mountains climbed and the rivers forged.

The somberness of their eyes is evidence of the demons they have faced down and the despair they have overcome.

And then there are those smiles.

Hallelujah for those smiles.

They tantalize, "Don't you wish you knew what I know" and "I've been there and did that before you even knew there existed."

The smiles assure, "Continue. Continue. You will work it out."

The smiles reassure, "Life is worth the living of it. Do it with your whole heart."

Kudos and salutes to the brave-hearted, keen-eyed Chester Higgins Jr. His intrepid spirit, which encouraged and allowed him to come lens-to-face with these human histories, tells us that in his time, when the years wrap softly around his frame and further into his soul, he will be looked upon, thanked, and praised as an Elder of Grace himself.

This book proves that he has the wherewithal.

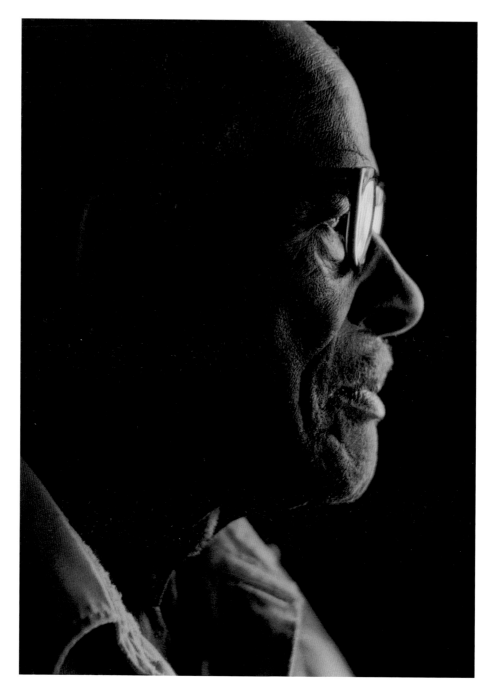

*"Whatever you do, it's important that you make a mark on life, or else you could very well die undeclared."*

MARCH FORTH McGOWAN, 4 MARCH 1890–1 MARCH 1998

My great-uncle's statement inspired my young soul and gave me focus. May his soul rest in peace.

# Acknowledgments

This book wouldn't have been possible without the support and encouragement of the many who share my conviction that aging should not be regarded as an affliction. It is a stage of life, like all others, that deserves to be celebrated and documented in all its natural grace and beauty.

I wish to give special thanks to my text collaborator, Betsy Kissam, who encouraged me to resurrect this project; my agent, Sandra Dijkstra, who believed it should be done; Barrie Novak, Zachary Morfogen, Toni Fay, Lorraine Leong, Lori Merritt, Connie Higgins, Cheryl Polk, Ponchitta Pierce, June Terry, Arseman Yohannes, Kelly Marshall, Isisara Bey, C. Damani Higgins, Chester Redhead, Selma Jackson, Judith Keller, Howard Dodson, Judith Bell, Elma Brock, Michael Geffrard, Suzanne Goldstein, Archibald Gillies, Michael Anderson, Joel and Isolde Motley, Thelma Austin, Bettye Stull, Keiko DeLille for all their steady encouragement. At Bulfinch Press, I want to thank my brilliant editor, Karen Dane; publisher Carol Judy Leslie and senior editor Terry Reece Hackford; and production manager Sandra Klimt. I'd also like to thank designer Jean Wilcox; separation consultant Bob Hennessey; and separator Professional Graphics. All thanks for the masterly skills of Igor Bakht, who produced the brilliant silver-gelatin prints for this book. Thanks to all the people whose portraits appear in the book as well to the hundreds of others who sat for my portrait sessions. I want to particularly thank all the women who served up their special slice of pound cake and conversation. Finally, to the Chester Higgins Jr. "Foundation" for financing this personal project with personal funds.

# Introduction

In the course of life when we are younger, we want to be older. But as we age, we flip-flop—we want to stay young.

Perhaps this is a universal truth, but there can be no doubt that it is especially accurate today. We as a society do not honor our elders, and as a result very few of us are emotionally comfortable within our older bodies. Today, individuals who blossom and season well are on their own special paths. They are beacons, in my mind—perhaps even national treasures, which we as a society need not only to appreciate and applaud, but to study and emulate. Refusing to give in to the societal pressures of ageism, these people are proud survivors who have relied on their inner selves and instincts.

Is it our fear of becoming useless and a burden that causes us to avoid and deny our natural destiny? Is it whole industries built around looking young forever that have caused us to shun aging as distasteful and unappealing? Obviously there is no clear-cut answer. But as with any stigmatized segment of our society, there are always those individuals who go against the tide and see themselves for who they are. These are people who are comfortable within themselves—who have attained the seasoned dignity and grace that only older age can impart. These are the people that I sought out for this book. Many I met by chance; faces full of character and insight caught my attention. Some are folks recommended to me by people who, when they learned of this project, excitedly encouraged me to visit the one, two, or more older people whom they revered and admired.

Never has a project given me back so much personally. Inside these gray-, silver-, and white-haired individuals, I found so much wisdom. Some of these elders know the value of what their minds have distilled from years of living; a few do not. "I am a divine work in progress," Rhoda Harris told me. Mrs. Harris is an eighty-seven-year-old entrepreneur, whose packets of affirmation cards she calls "Rhoda's Wisdom in a Pouch" demonstrate a woman who understands the knowledge she possesses. All of us are divine works in progress. We are never static. We grow, we change, and we feel, we experience, and sometimes we evolve, but always we are progressing from who we were to who we are becoming.

As with every stage in life, there are drawbacks to aging. Perhaps my great uncle, Forth McGowan, said it best decades earlier when I was an eight-year-old bundle of energy and he was a gray-haired sixty-something: "If only I could have his energy with my wisdom," I overheard him tell his older brother.

Aging, I have discovered, is learning how to embrace new things. For some that means surfing on the Internet and being around today's youth; for others it is focusing on a mature talent or perhaps developing a latent ability, accepting a new direction, or deepening a commitment to family and relationships.

Learning was a big part of this project for me. I listened to folks speak from their experience. Trying to distill our conversations down to one or two sentences to suggest each individual's personality and vast store of knowledge was one of the hardest tasks in preparing this book. Over the course of the project, I like to think I may have given something back, too. When I first showed seventy-three-year-old Ruth George the portrait of her I planned to run in this book, she wasn't pleased. A week or so later, she confessed: "At first I didn't like the picture," she told me, "but as I studied it, I said, 'That's me.' I don't see myself as you saw me. I think of myself as forty; I don't think of myself as seventy-three. I remember myself, how I looked and sounded, and how I acted when I was forty. I looked in the mirror, but I didn't see a seventy-three-year-old face until you gave me that picture. That's the real me as I am today. And I'm beginning to appreciate what you saw in me."

We all need a "real" mirror now and then. I hope this book will encourage us as a society to face ourselves, individually and collectively. We need to stop denigrating ourselves—anxiously erasing the first sign of puffiness around our eyes, deepening wrinkles, and sagging muscles. We need to embrace these changes as natural and see the beauty of the person within; we must accept this elder stage in our lives, and glory in the strength of mind and character gained from years of living. Those who have wear the signs of character on beautiful mature faces.

Many of us already see this beauty outside of ourselves, in others. Who hasn't noticed a dignified elder with white hair, a beautifully creased face, or strong, gnarled hands that evoke respect? But what about ourselves—what is in each of us?

Years ago when I was still in my thirties, an older relative told me: "In my twenties, I was clueless as to who I was. In my thirties, I began to understand who I was, but I didn't like myself. In my forties, I accepted myself. In my fifties, I began to celebrate myself. In my sixties, I have blossomed. It can only get better."

I think I can safely say that for the people whose portraits appear in this book, life has gotten "better." Not necessarily easier, and definitely not without heartache, but they have told me over and over that they know they can face whatever comes their way . . . and why not? They have decades of experience, wisdom, and accumulated emotional resources to sustain them.

I hope the spirited men and women in *Elder Grace* reflect a new trend in our vision of ourselves and our society. We are all truly "divine works in progress."

CHESTER HIGGINS JR.

*"If we do not honor our ancestors, there will be no one to honor us."*

Miriam B. Francis

IN THEIR *H* EARTS

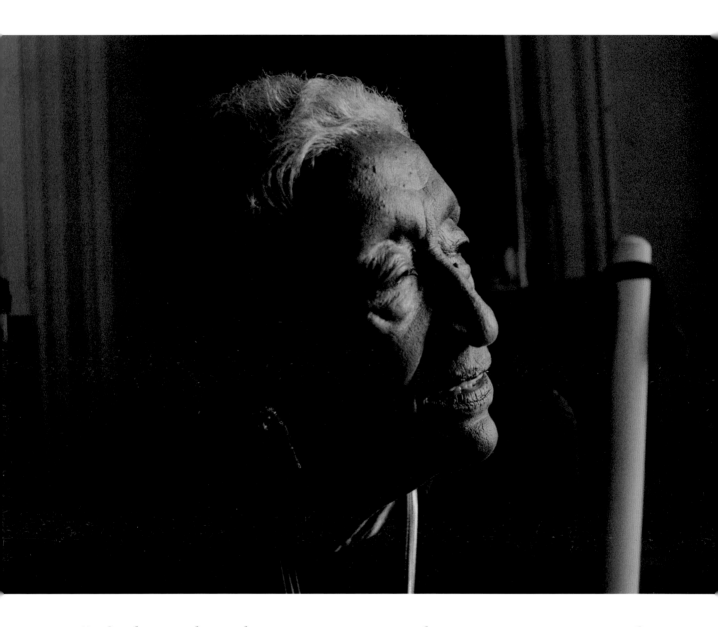

"It has become almost obsessive for me to open a door to a young person. Everything that I know, I'm absolutely compelled to turn it over to younger people—preferably blacks and preferably women, but to others." EVELYN CUNNINGHAM

"Your values change as you walk your journey. I have found that the things I value today have made me happier. I can bounce off bad things and keep on going. I have resilience." MARIE BROOKS

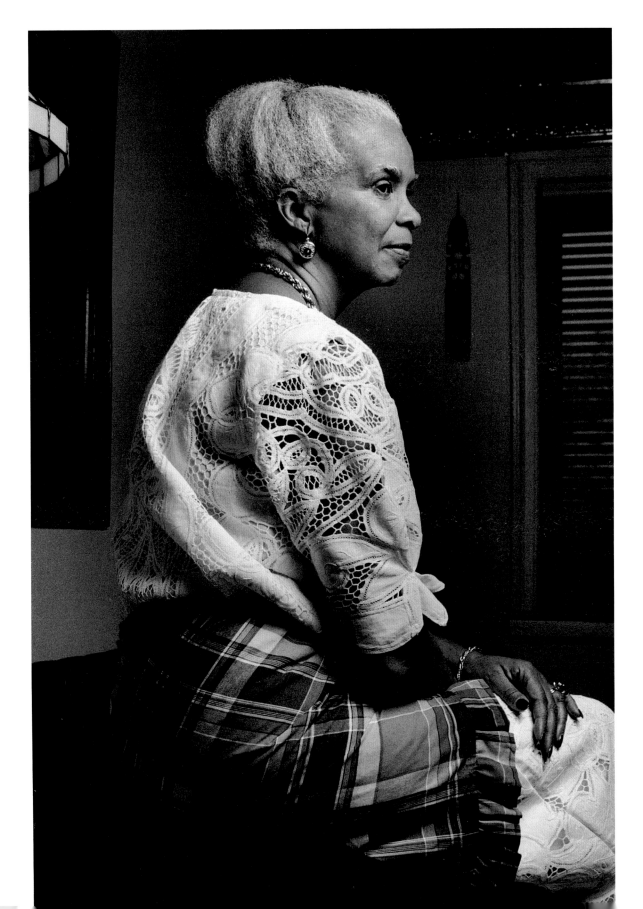

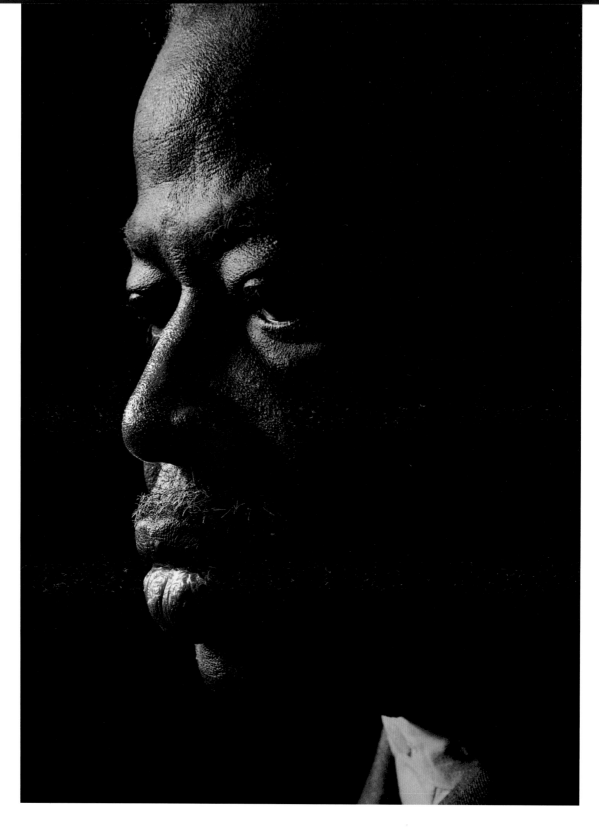

*"My concept of what it means to be an African is being in love with yourself."* YOSEF BEN-JOCHANNAN

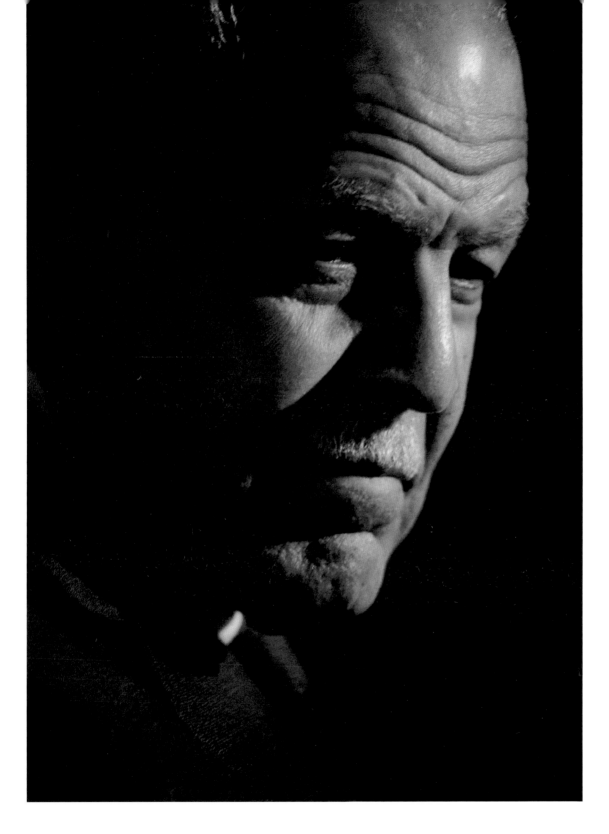

"We learn very largely from our failures. So we must rejoice in them and try to move beyond them to ultimate successes." SAMUEL W. ALLEN

*"Once you put yourself down, you are in trouble. You must be good to yourself before you can be good to anyone else."* BERNICE NONA STAGGERS

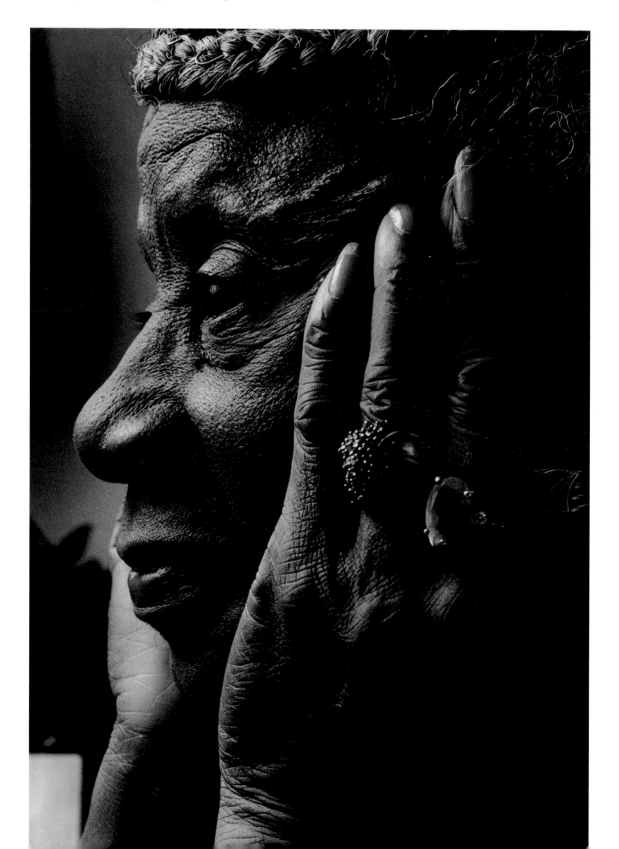

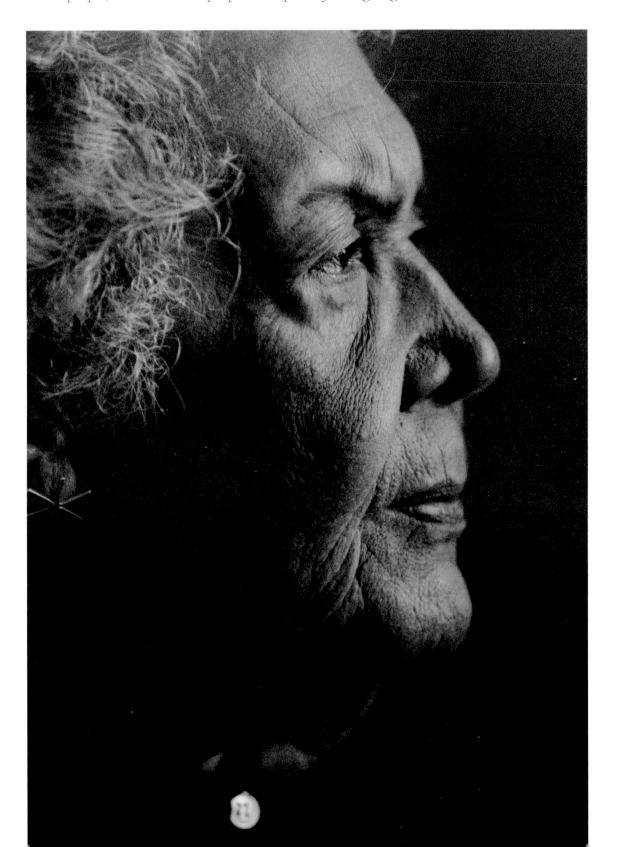

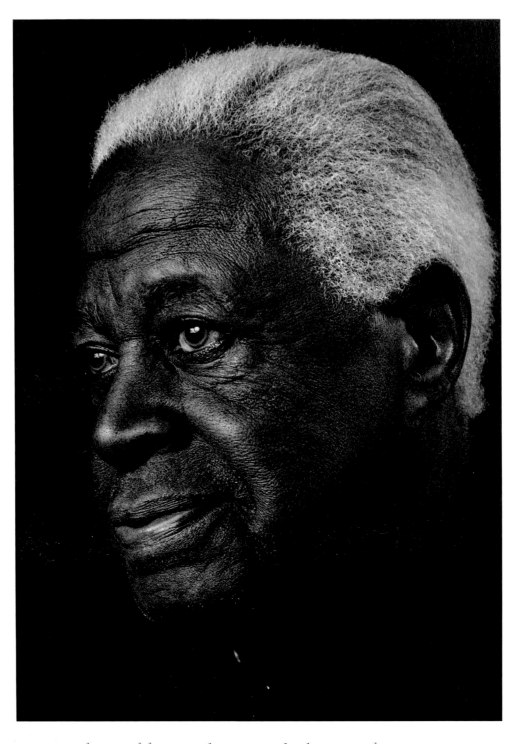

*"Those who are successful prevail because they never think negatively of themselves or the circumstances surrounding them. They never give up."*

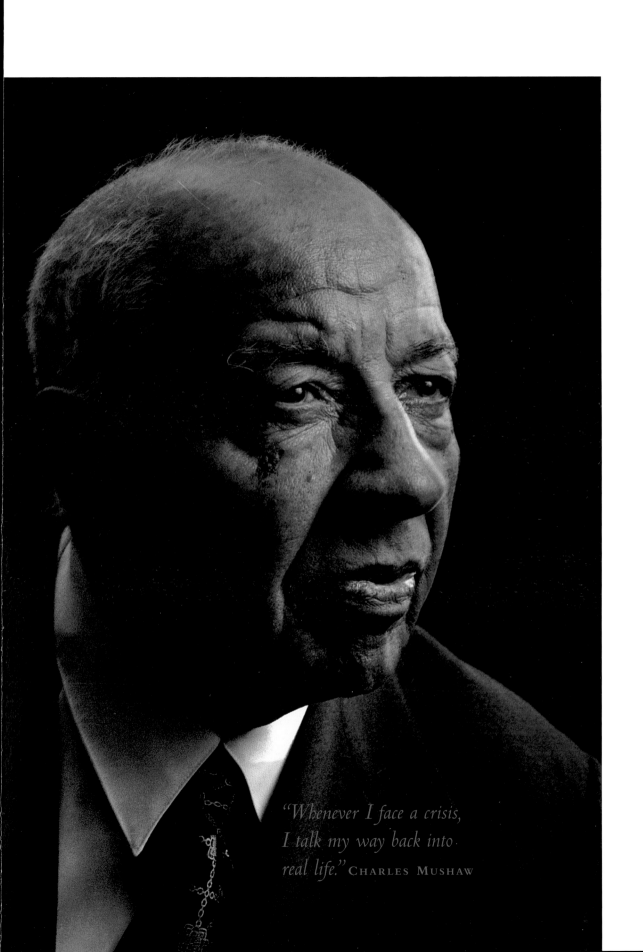

"Whenever I face a crisis,
I talk my way back into
real life." CHARLES MUSHAW

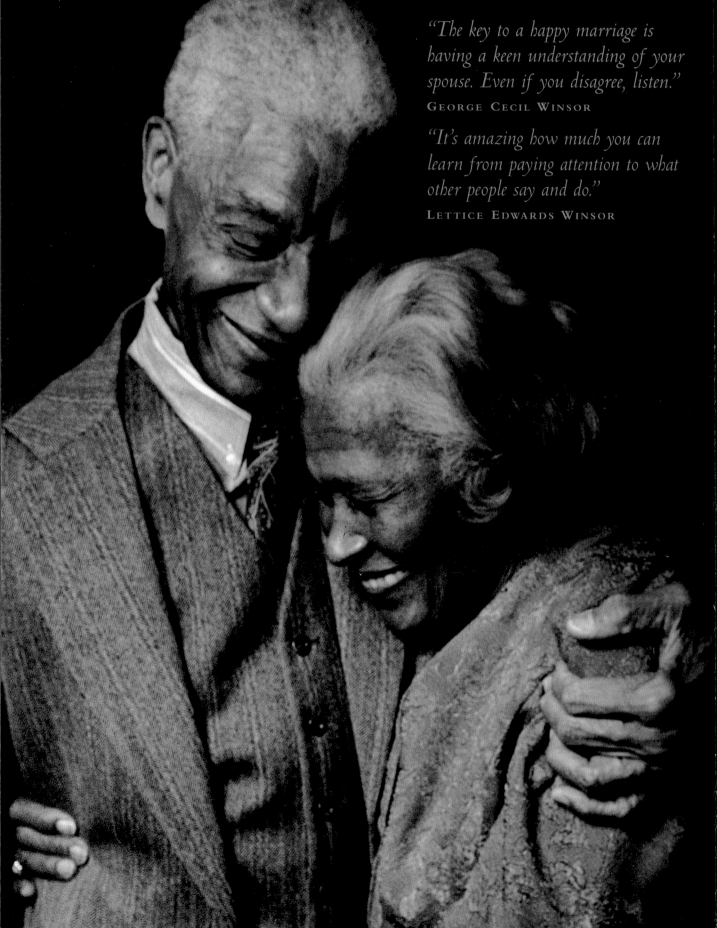

"The key to a happy marriage is having a keen understanding of your spouse. Even if you disagree, listen."

GEORGE CECIL WINSOR

"It's amazing how much you can learn from paying attention to what other people say and do."

LETTICE EDWARDS WINSOR

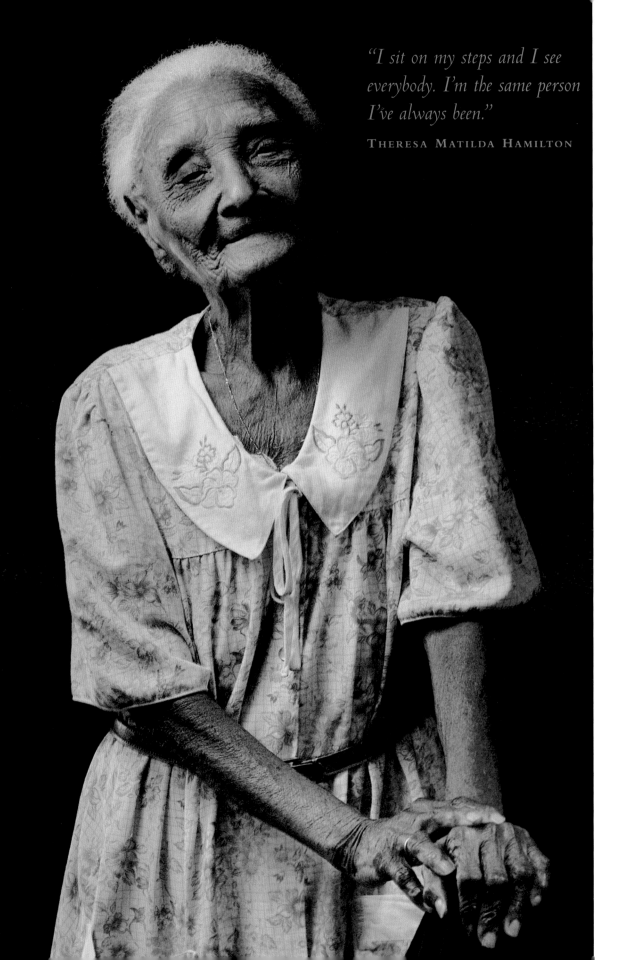

*"I sit on my steps and I see everybody. I'm the same person I've always been."*

THERESA MATILDA HAMILTON

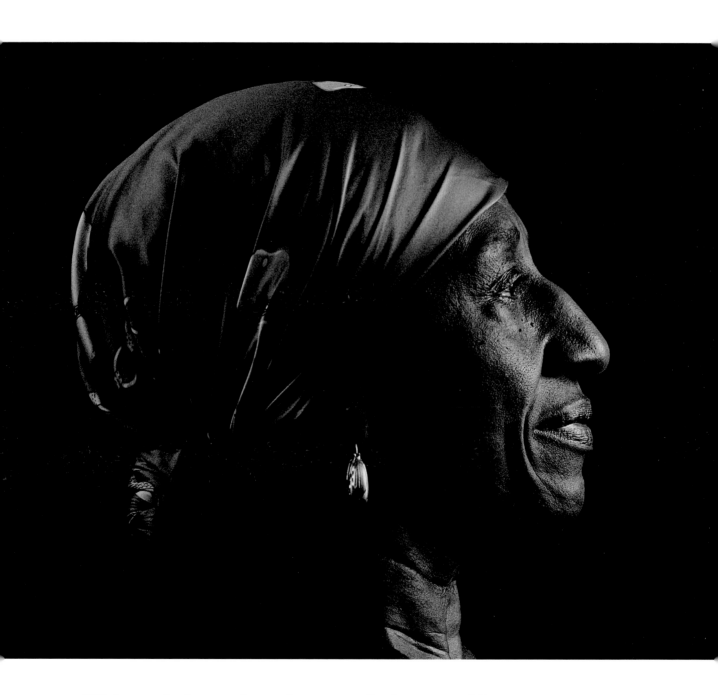

*"With friends, know when to be quiet and when to speak."* LOIS C. ROBINSON

*"The most important thing anybody can do is get rid of guilt. All guilt is self-destructive. We have been taught that if we feel guilty, we need to be punished. When we feel guilty, we are punishing ourselves."* LOUISE MERIWETHER

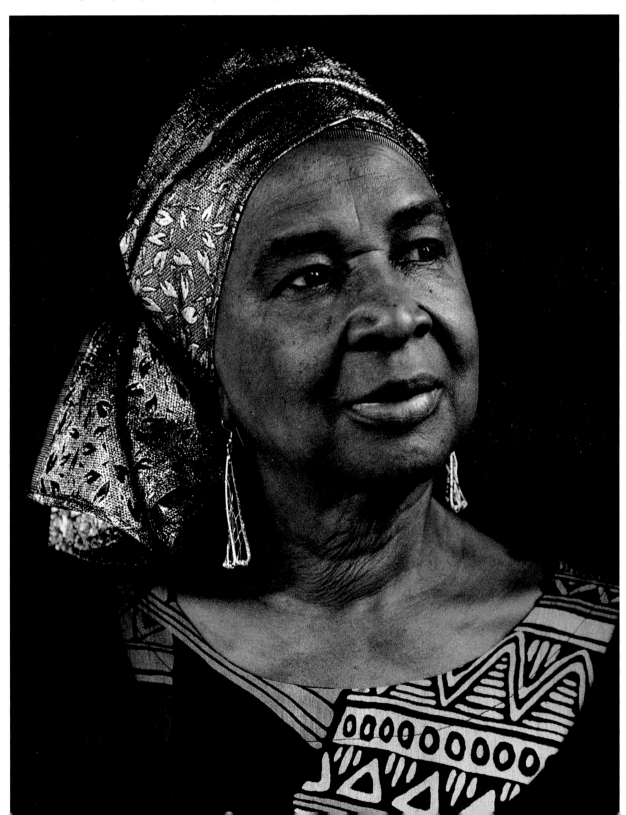

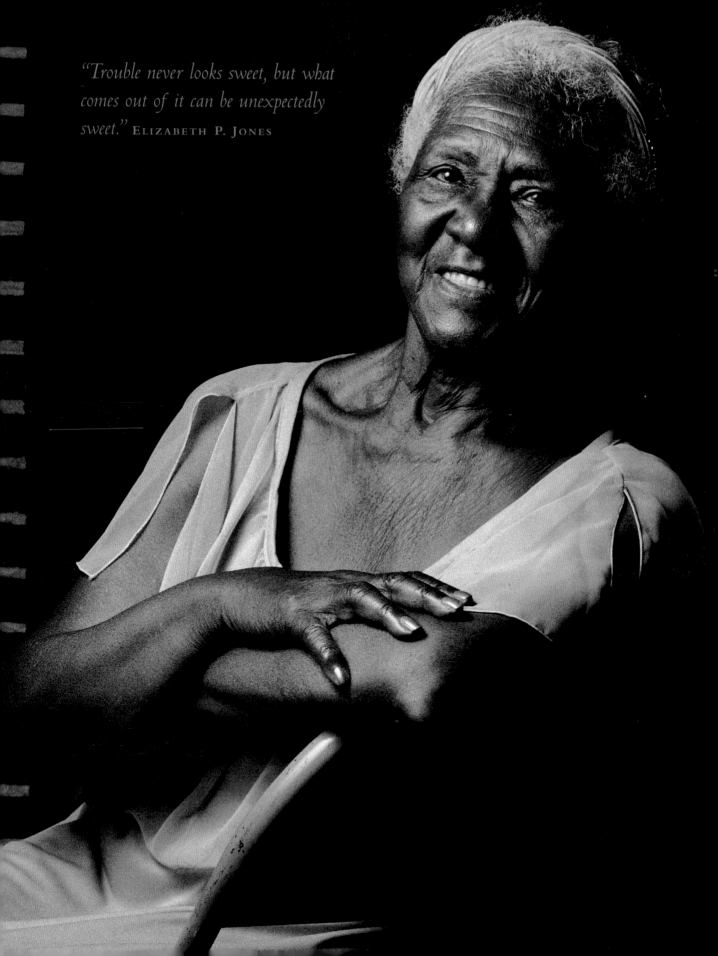

*"Trouble never looks sweet, but what comes out of it can be unexpectedly sweet."* ELIZABETH P. JONES

*"The important things in life are love, understanding, and education."*

GLORIA HUNTER

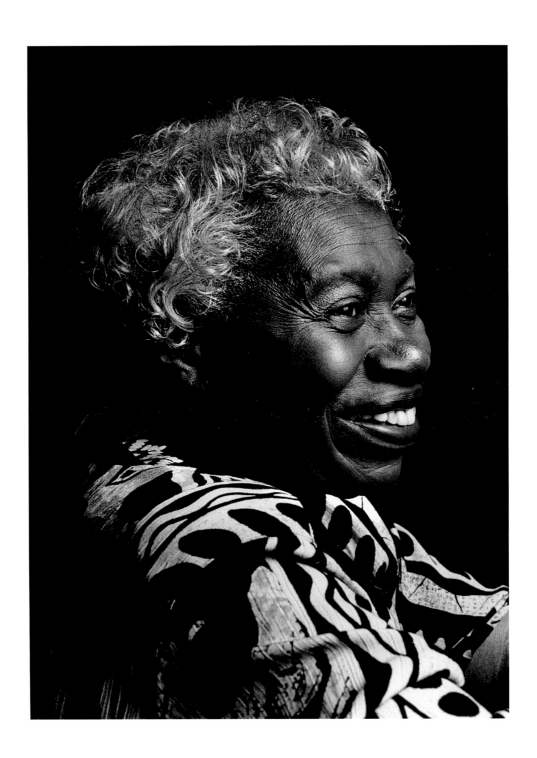

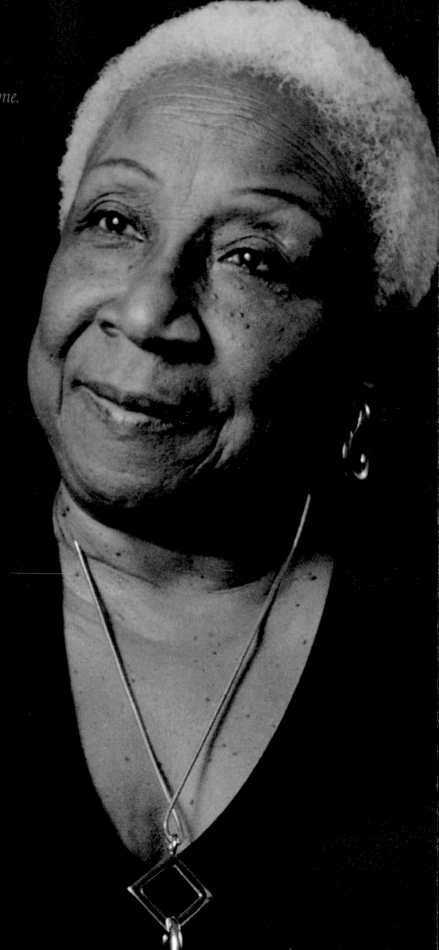

"*Education is the only key.
It has always been important to me.
My mother was a teacher.
My grandmother was a teacher.*"

PEARL I. ROMEO

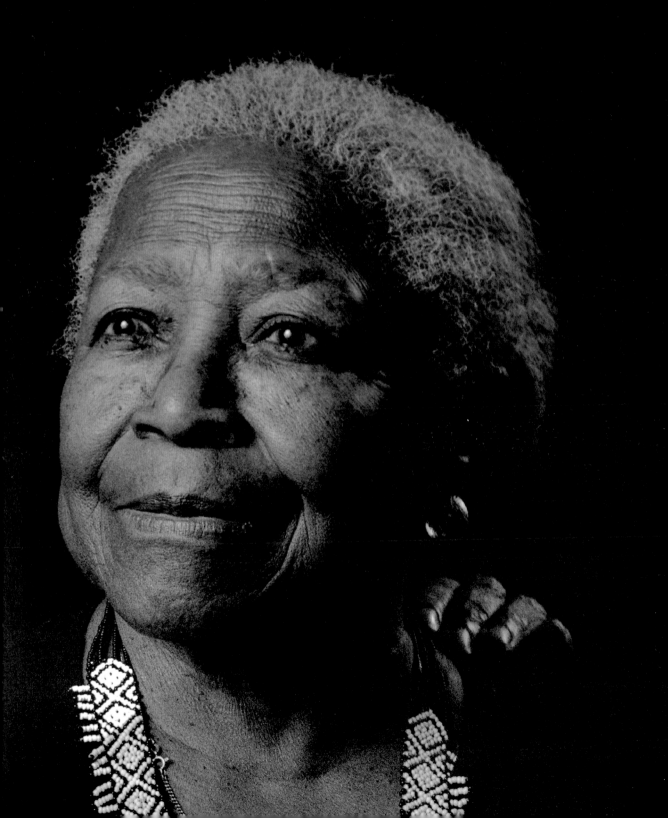

*"It's not what you tell me, but the manner in which you say it."*
IANTHE DELILLE

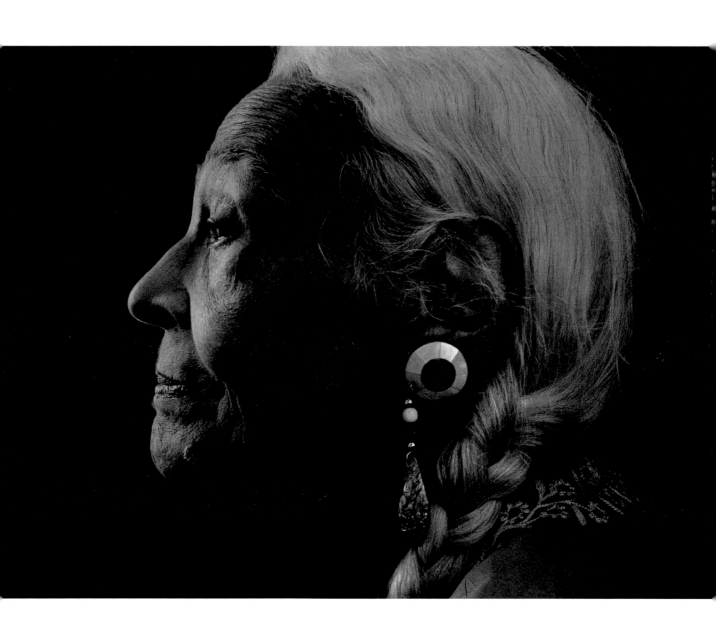

*"When I was younger, I trusted everybody. When I grew older, I learned everyone is not alike. Now, I know more about people, and I'm more careful."*

STEPHANIE BURNS

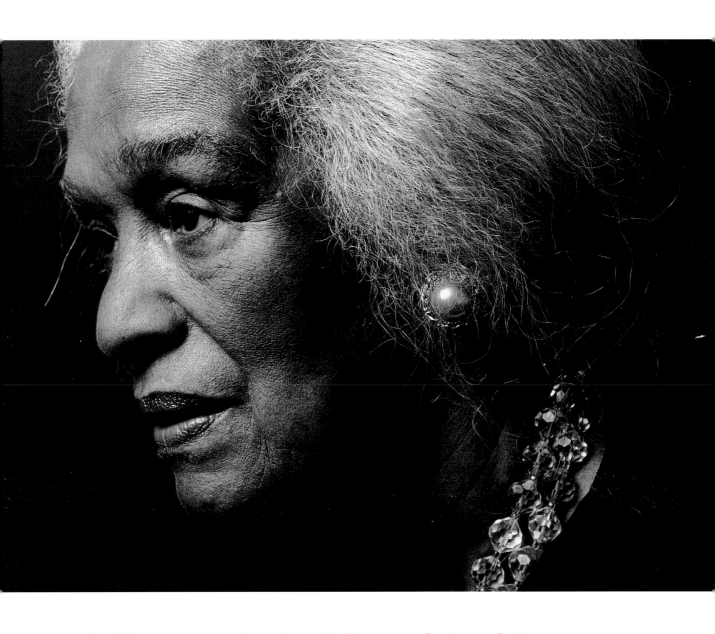

"*Children can't rear themselves. Children must be chastised. They have to be taught, and if you don't teach them they will not know.*"

ARINA LATHAM-HOLMES

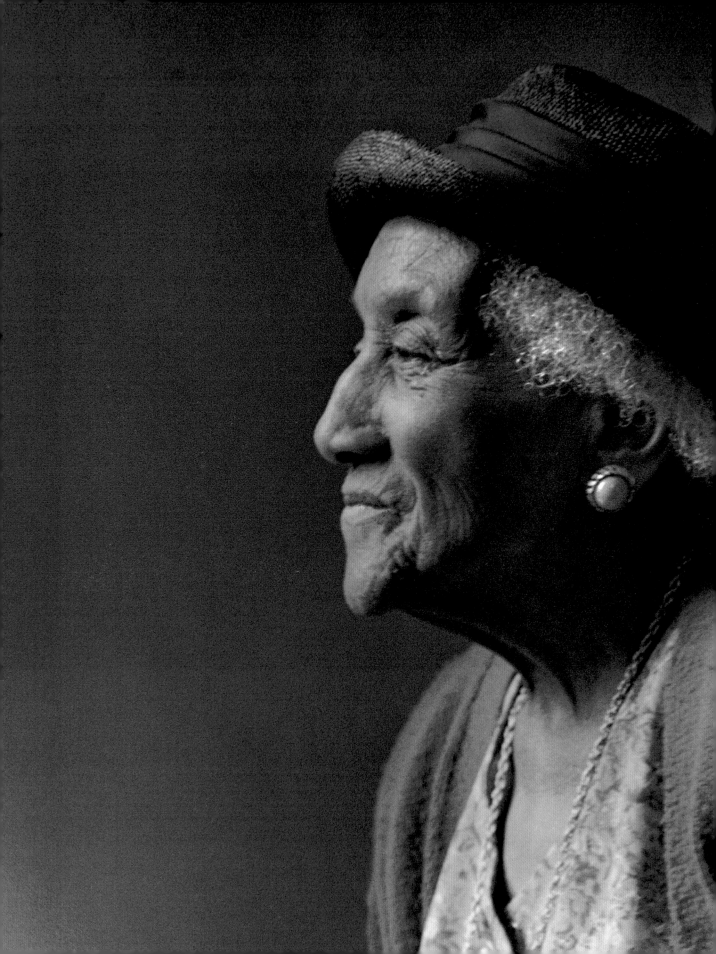

"When people are
always finding fault,
I tell them there can't
be something the mat-
ter with everyone,
there's something the
matter with you."

MARIE PAYNE

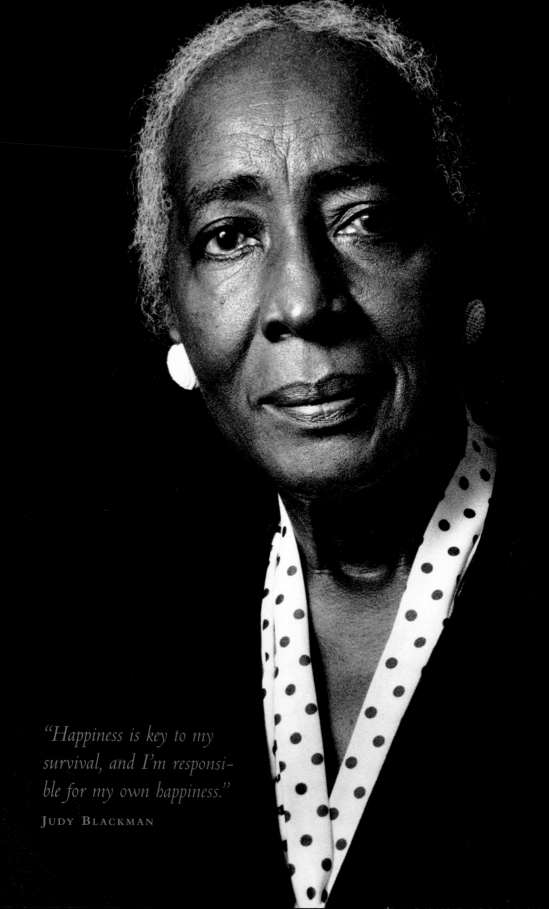

"Happiness is key to my survival, and I'm responsible for my own happiness."

JUDY BLACKMAN

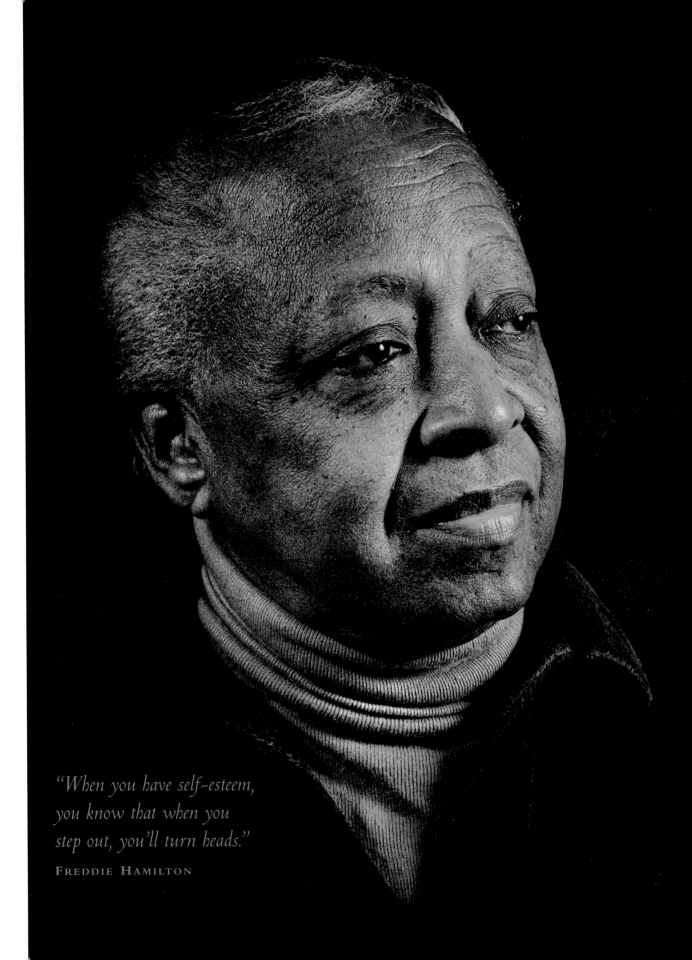

*"When you have self-esteem,
you know that when you
step out, you'll turn heads."*

FREDDIE HAMILTON

"I told my children, I'm not here to tell you what to do but to help you do what you want to do." LUTHER WILLIAMS

# THE GENERATION OF US

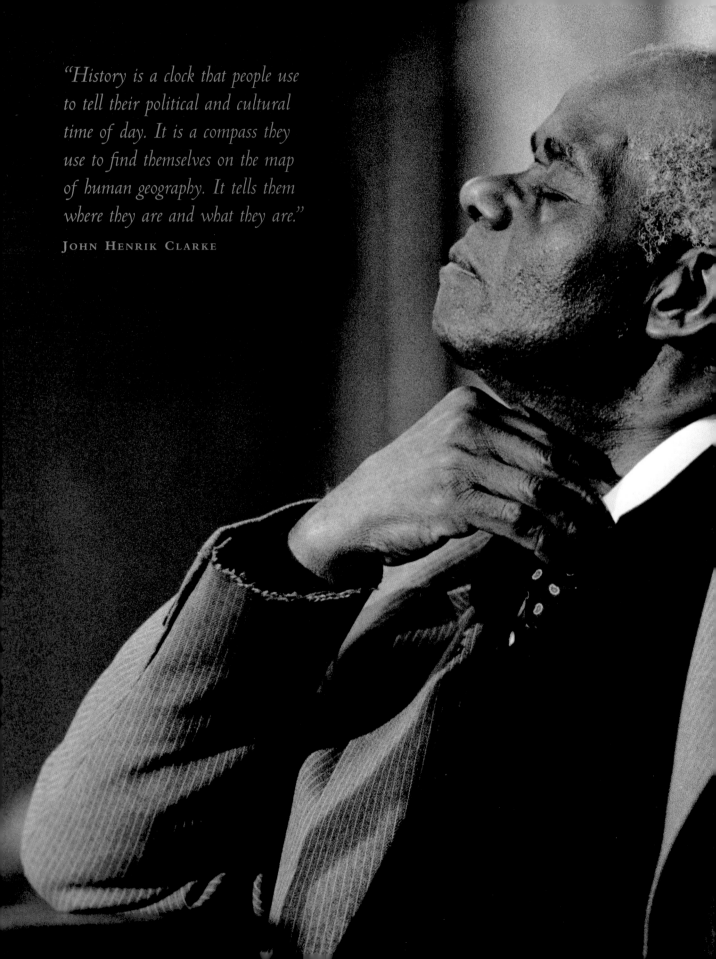

"*History is a clock that people use to tell their political and cultural time of day. It is a compass they use to find themselves on the map of human geography. It tells them where they are and what they are.*"

JOHN HENRIK CLARKE

*"I know who I am. Being me is important to me."* MARIA ORTIZ

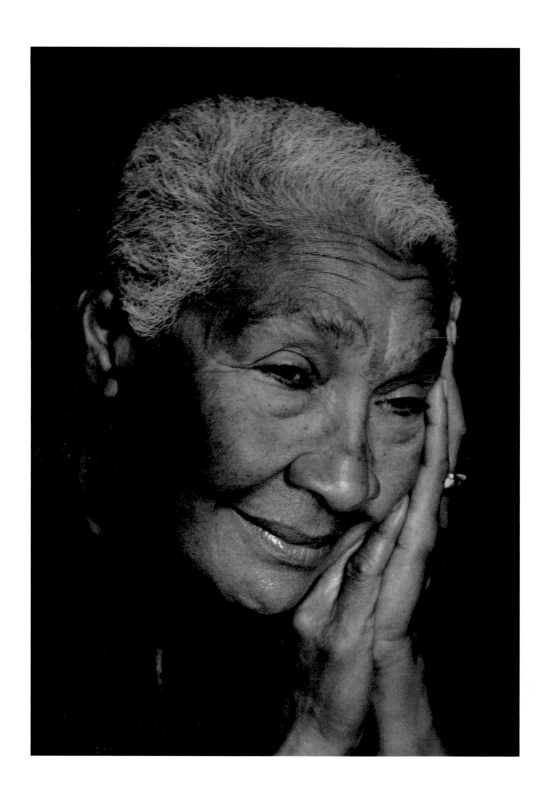

*"Teach your children by exposing them to things, take them different places, and show them how things operate. Make sure they are well mannered and choosy about the company they keep."* MARGARET INEZ WHITNEY

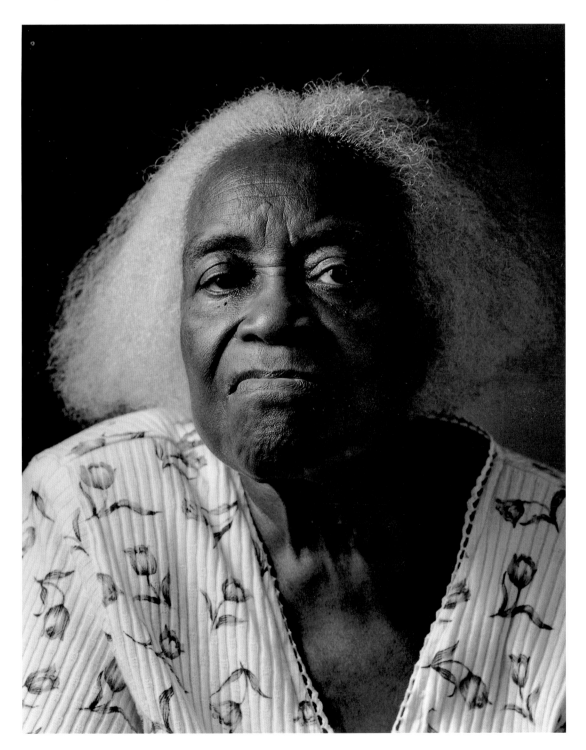

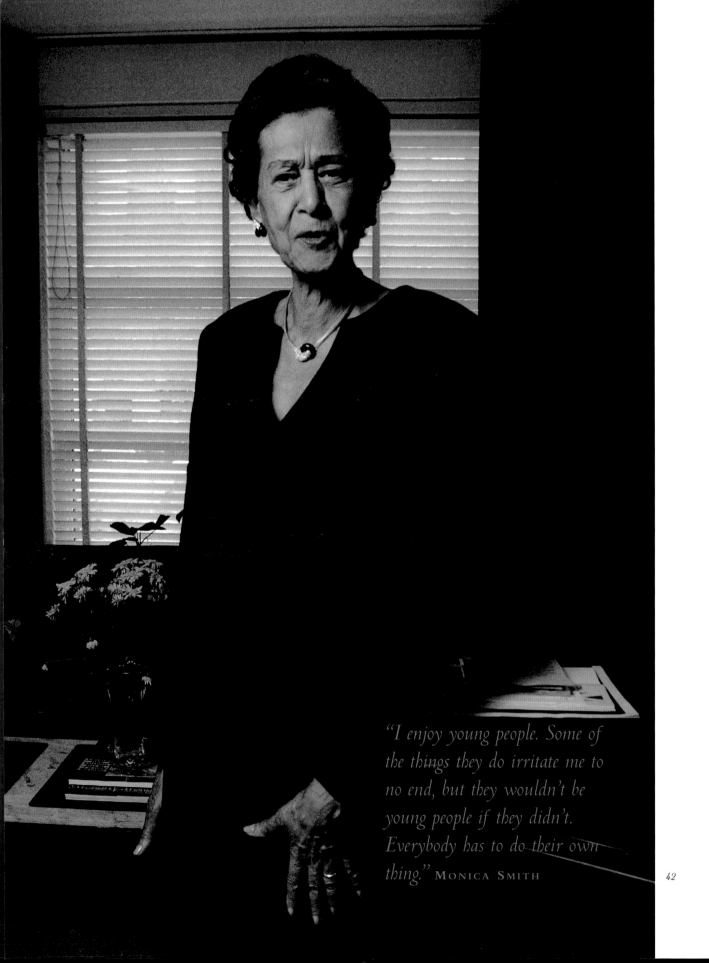

*"I enjoy young people. Some of the things they do irritate me to no end, but they wouldn't be young people if they didn't. Everybody has to do their own thing."* MONICA SMITH

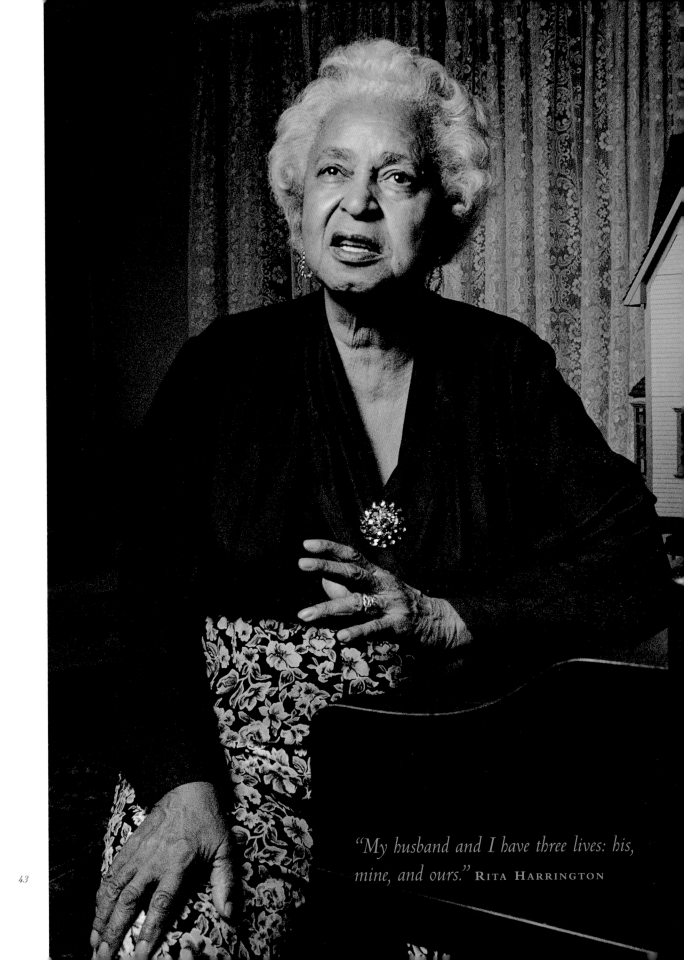

"My husband and I have three lives: his, mine, and ours." RITA HARRINGTON

*"God blesses us so that we all have the things we need through his grace. The things we want, we have to get for ourselves."* ALFRED DAVID HOLMES

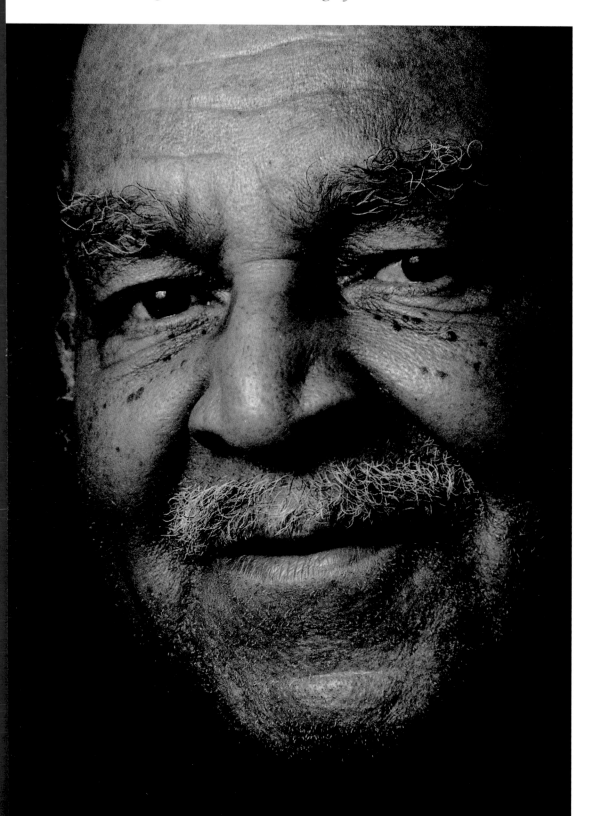

*"When you see an objective, think about how you can do it, and then do it."* GILBERT HINES BANKS

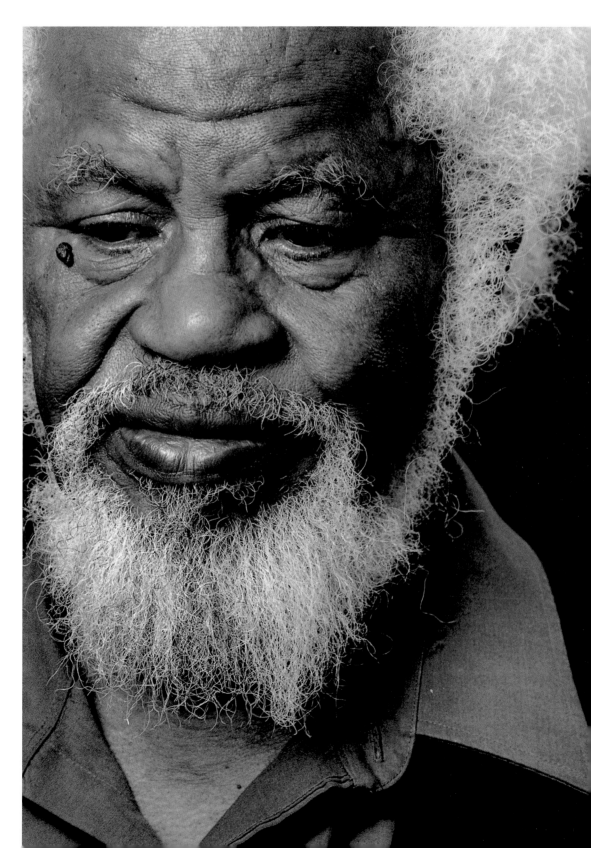

*"Anybody can make a mess. You have to work at raising kids."*
MARJORIE COULTHURST

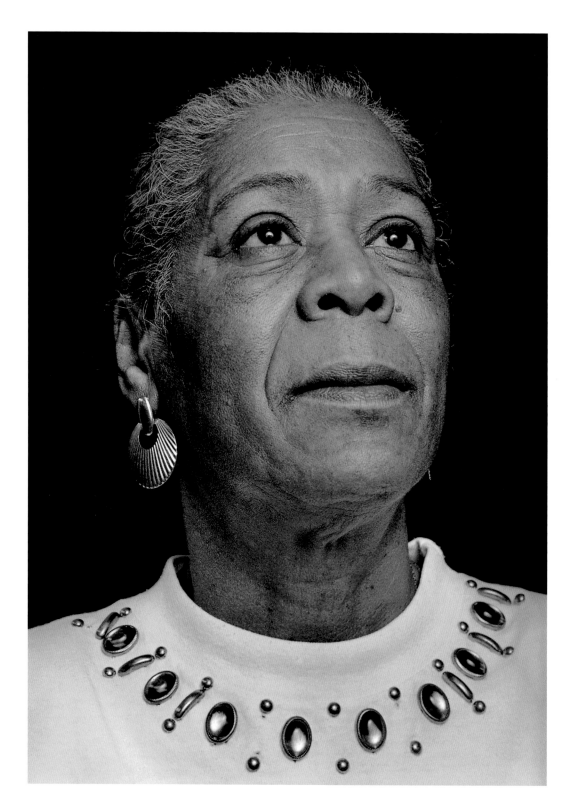

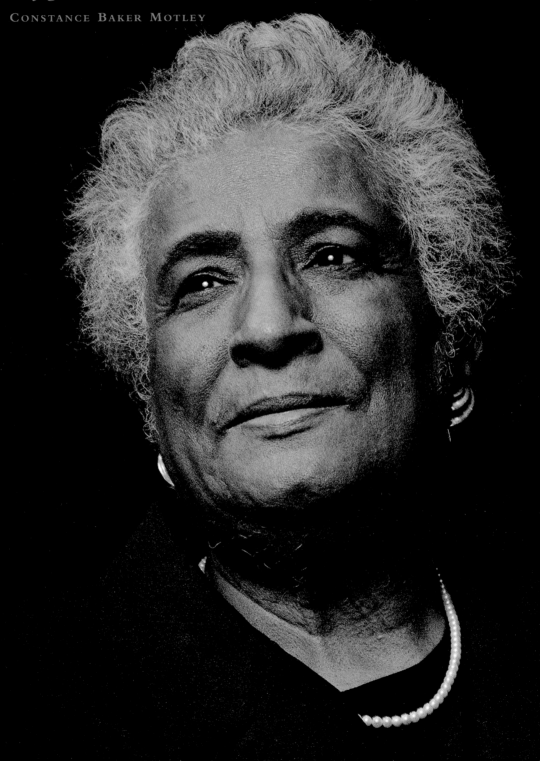

*"My grandchildren make me realize I will live on after my death."*
CONSTANCE BAKER MOTLEY

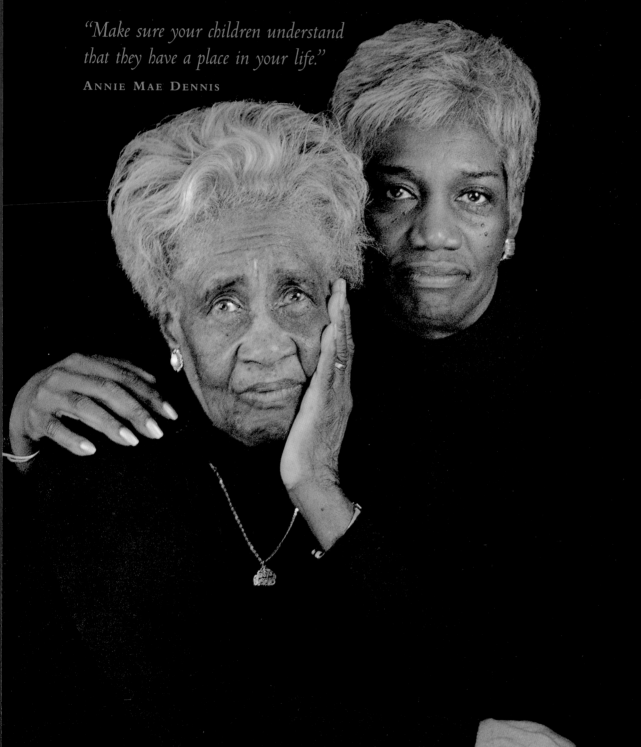

"Make sure your children understand that they have a place in your life."
ANNIE MAE DENNIS

"She was a hard worker, and we always saw that." MINNIE JONES

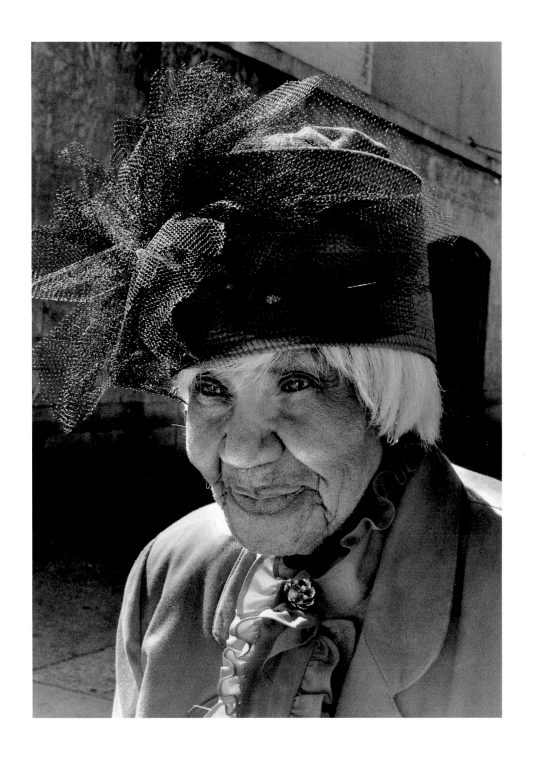

*"Good friends are presents from God."* Beatrice Stroud

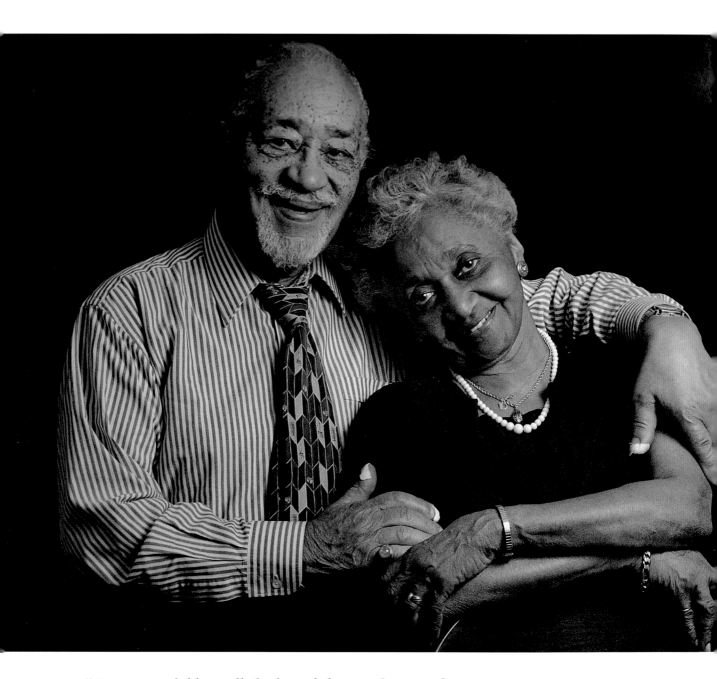

*"Give your children all the knowledge you have, and they'll come out all right."* WILLIAM R. HUDGINS

*"Have positive relationships. I don't believe in dealing with people who are hostile or try to put me down."*

DOROTHY C. HUDGINS

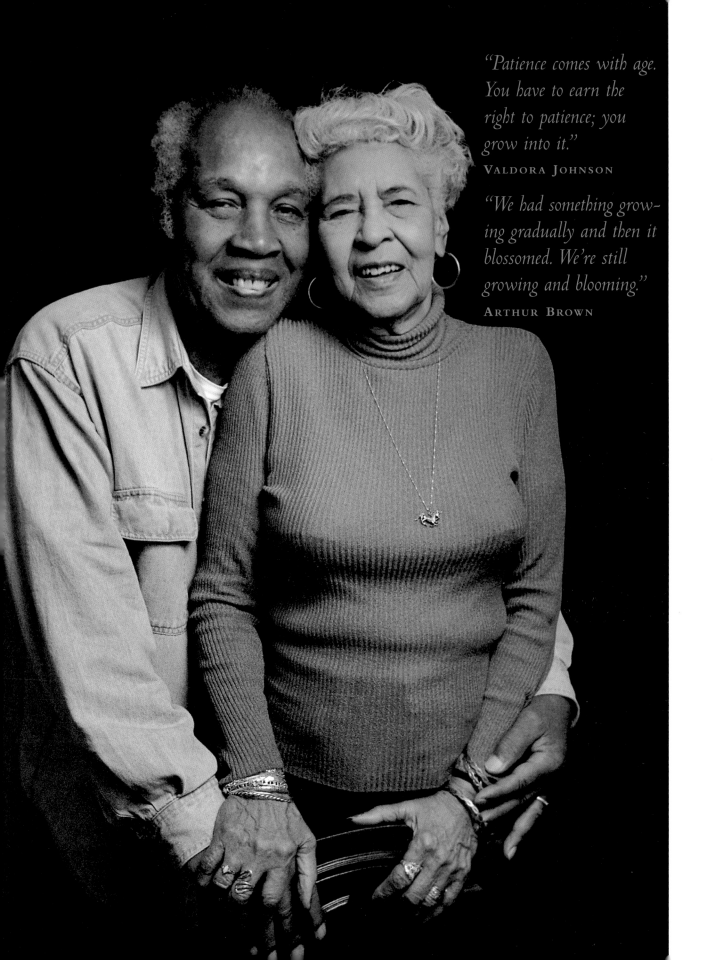

*"Patience comes with age. You have to earn the right to patience; you grow into it."*
VALDORA JOHNSON

*"We had something growing gradually and then it blossomed. We're still growing and blooming."*
ARTHUR BROWN

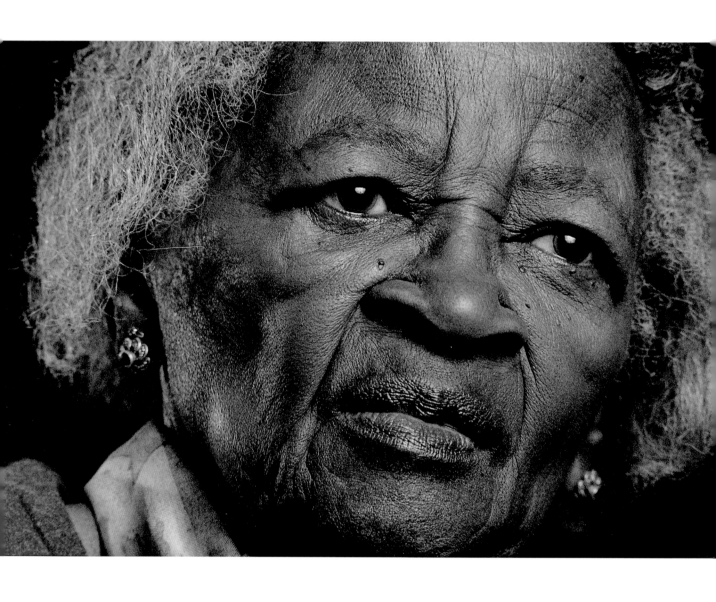

"I visit nursing homes and hospitals, people who are shut in—people who are much younger than I am." SUSIE CRAIG

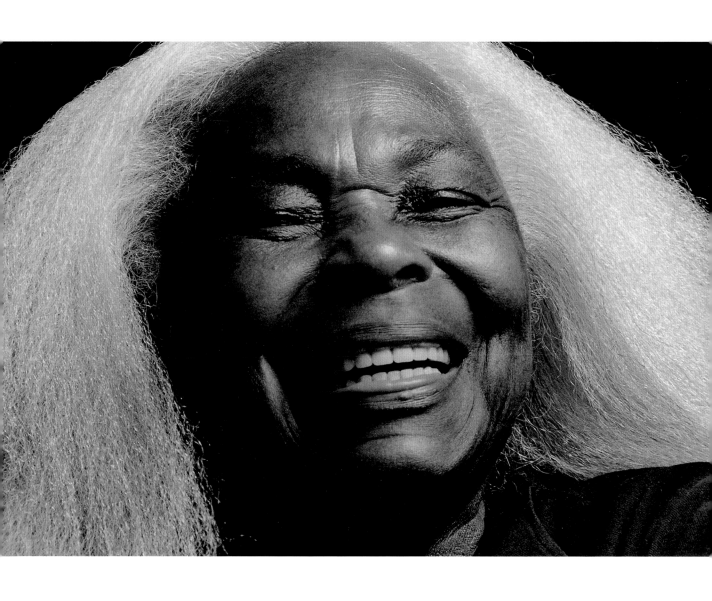

*"A single parent with love can do miracles."* JOYCE MAYFIELD WATSON

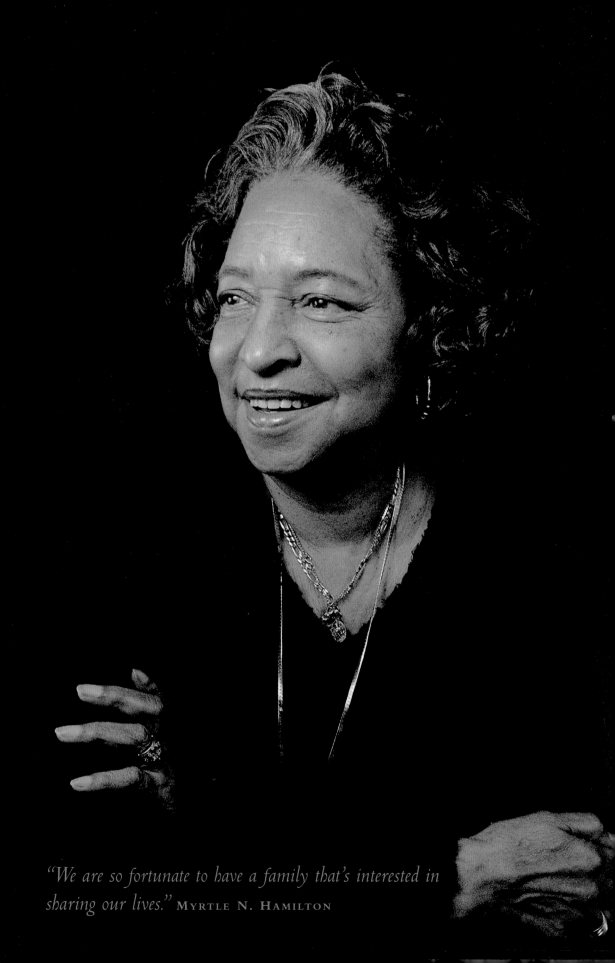

*"We are so fortunate to have a family that's interested in sharing our lives."* MYRTLE N. HAMILTON

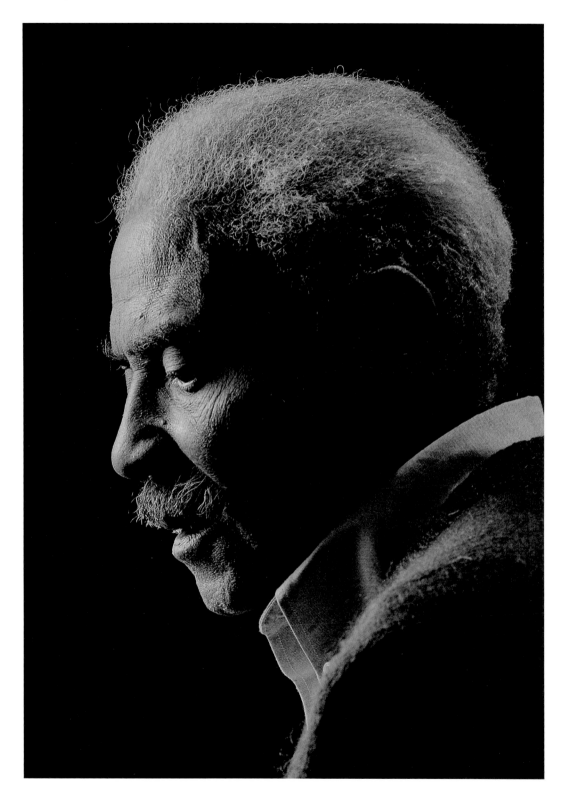

55 *"I continue to draw and paint. I am still growing and learning, and have great expectations."* HARTWELL YEARGANS

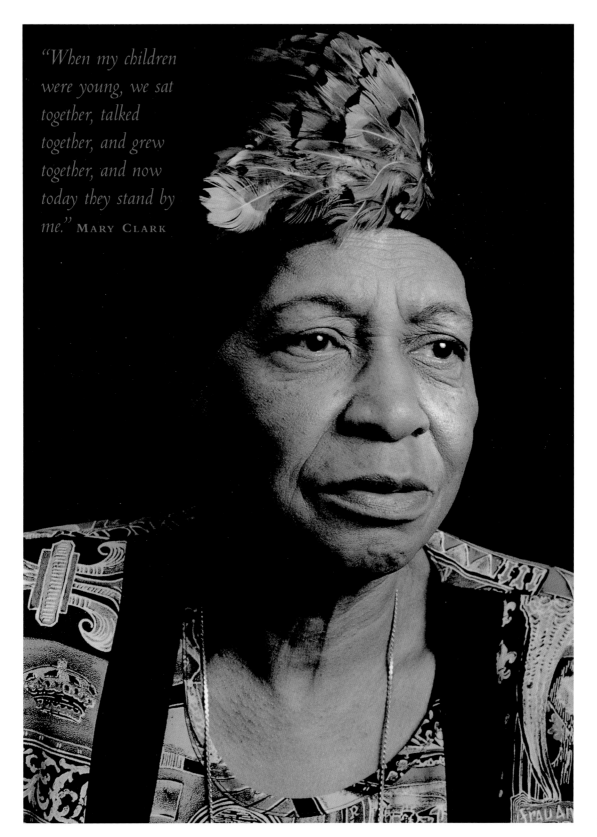

"*When my children were young, we sat together, talked together, and grew together, and now today they stand by me.*" MARY CLARK

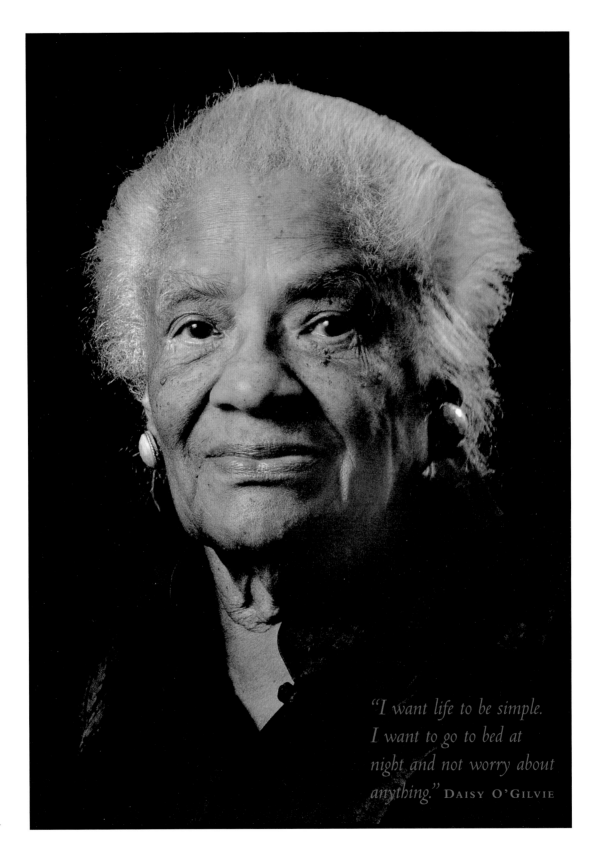

"I want life to be simple. I want to go to bed at night and not worry about anything." DAISY O'GILVIE

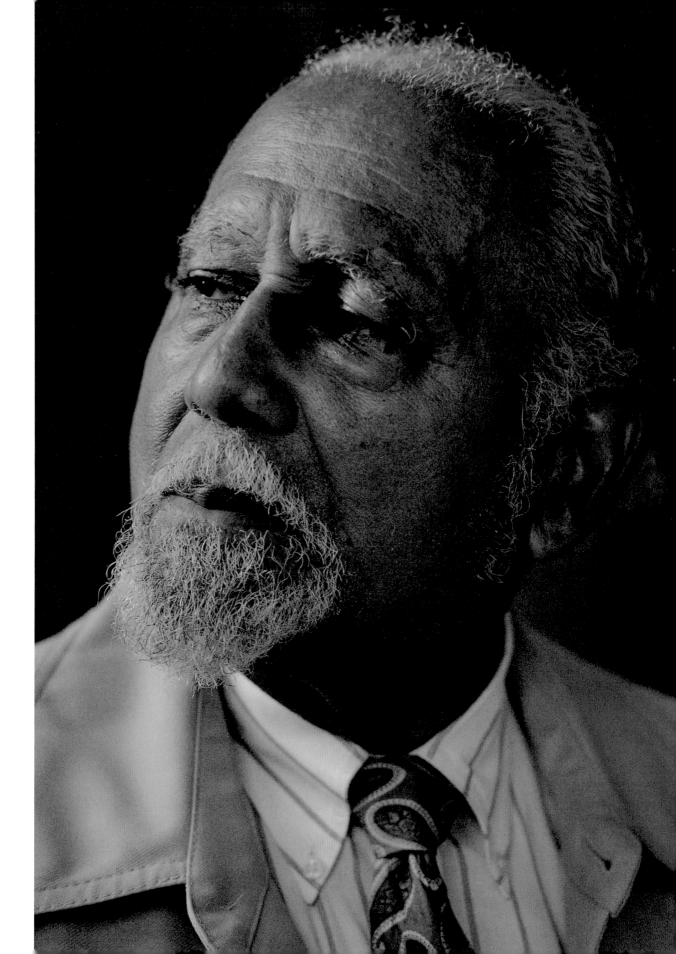

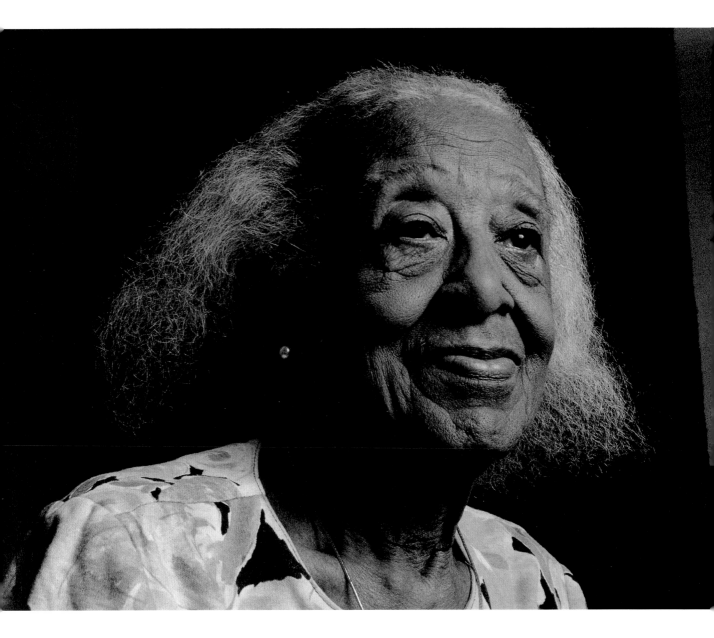

"*Be a good friend, and you'll get it back.*" MAUDE CHRISTINA LANDIN

< "*You have to express your feelings about different things, no matter what they are. You should be diplomatic, and sometimes that's hard for me, but I feel better inside for having spoken out.*" LEONARD NELSON NAPPER SR.

*"Every day I'm as young as I want to be and as old as I have to be."*

RHODA A. JONES HARRIS

# DIVINE Works in Progress

*"When I open my eyes in the morning and see the sun streaming in, or even if it's raining, I say, 'Thank you, God, for another night and for bringing me into this day.'"*

FAUSTINA P. ALBURY

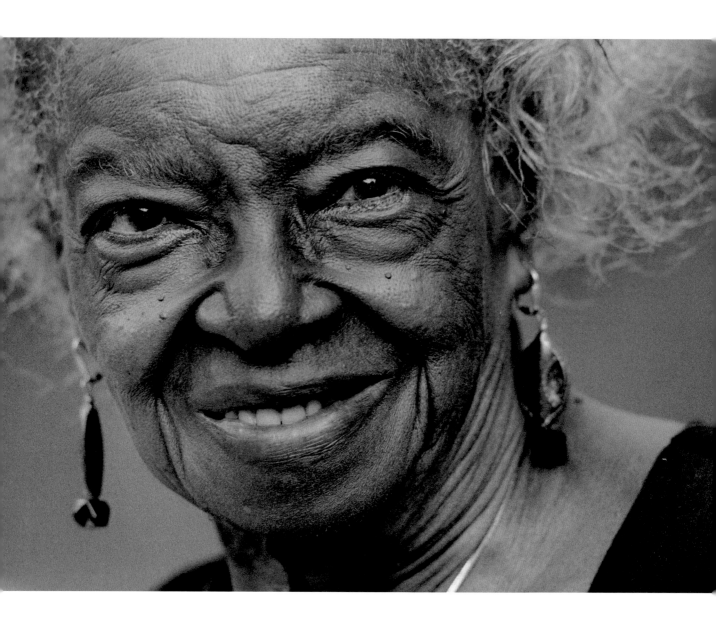

*"I work with children out of love. They come into the world as innocents. There are no bad children. It is what we as adults make for them that counts."*

RUTH WILLIAMS

>

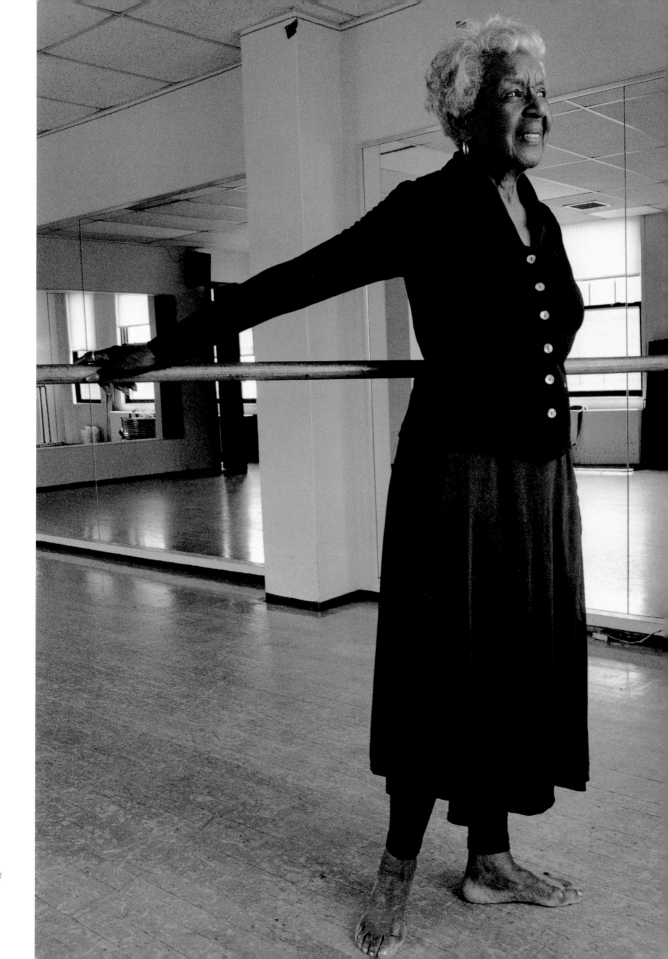

*"I've learned to love myself. I didn't know that you should. If you don't love yourself, you can't love anybody or anything."* MURIEL HARRIS

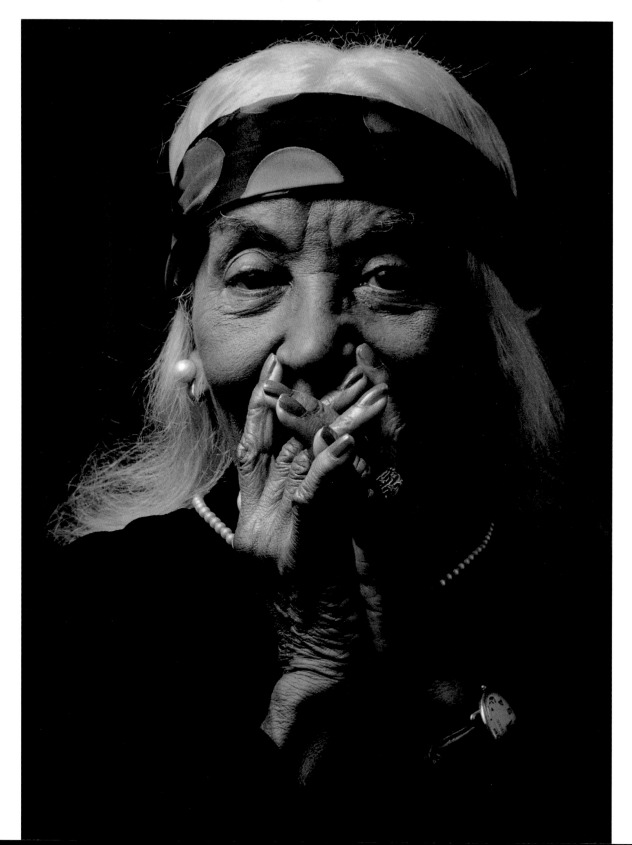

*"If you really want to be something in life, you will be."* M<small>ARVIN</small> P. S<small>MITH</small>

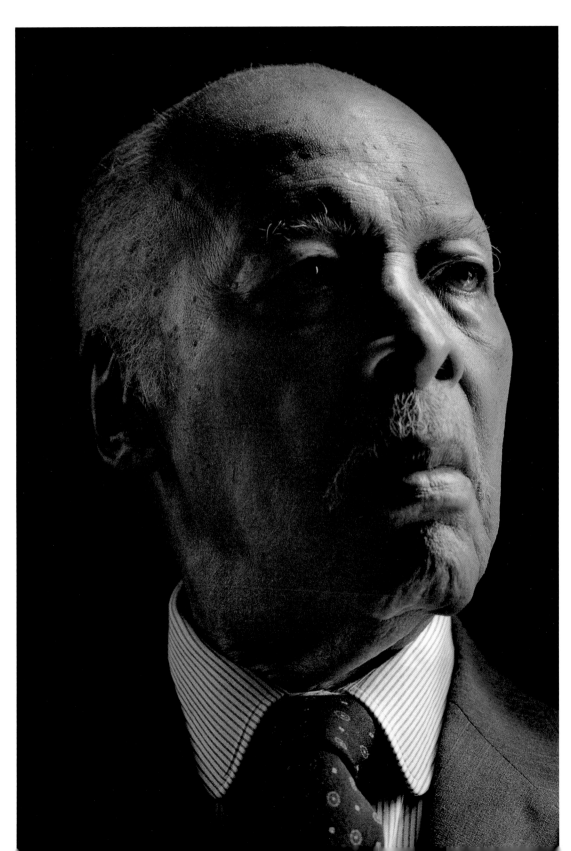

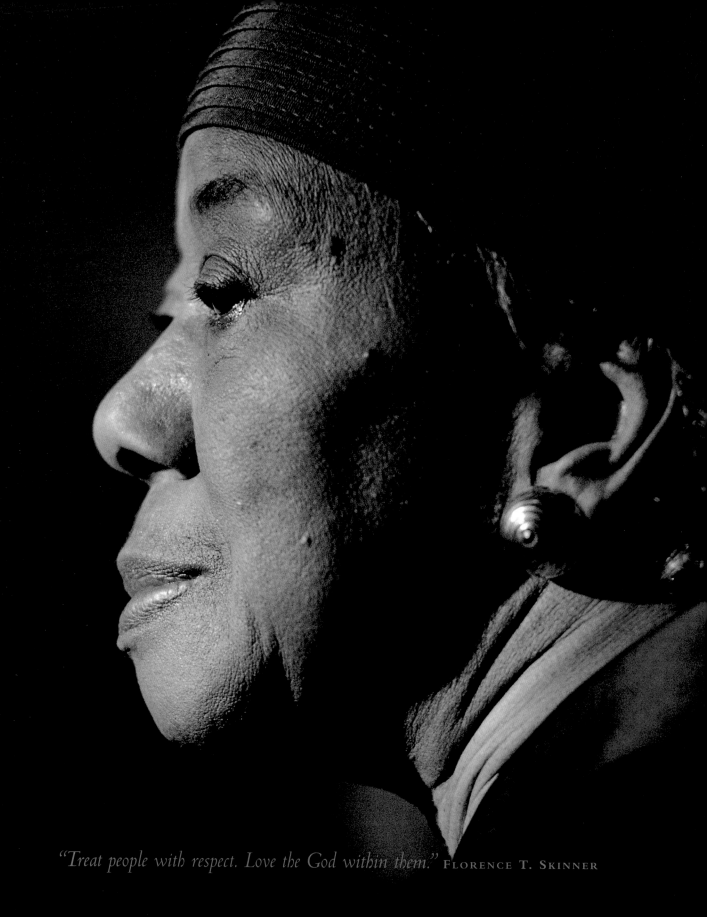

*"Treat people with respect. Love the God within them."* Florence T. Skinner

*"Live, and live fully. There is always an unanswered question, and if you live long enough, the secret might well be revealed. I think truth is worth waiting for, and age is an access to truth."* OSSIE DAVIS

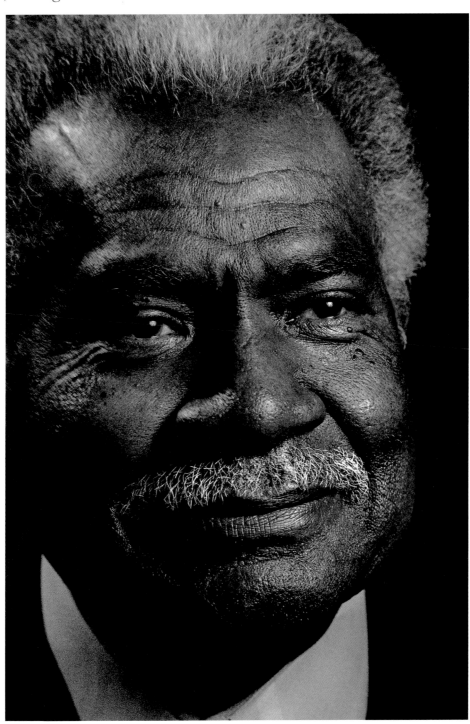

*"I put a great deal of emphasis on positive affirmation. It is my mental fertilizer."*

RHODA A. JONES HARRIS

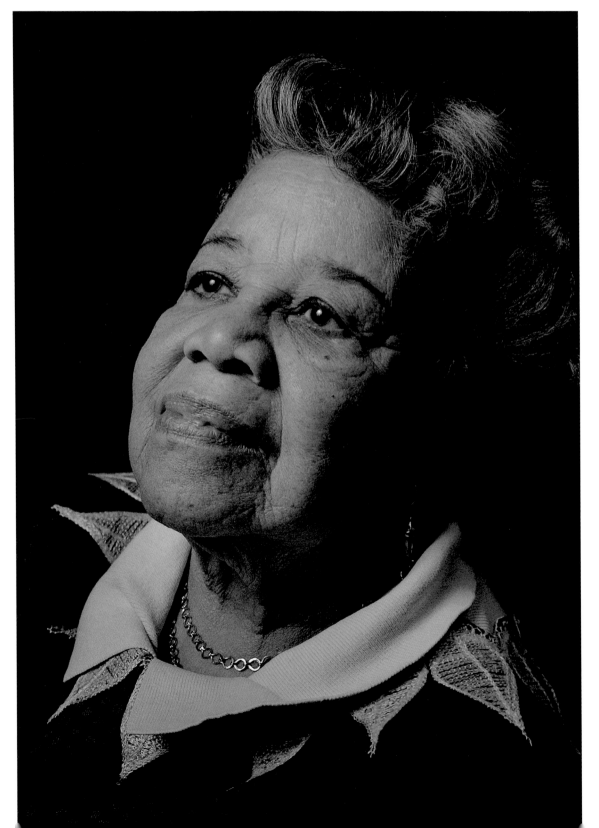

*"Separate your wants from your needs, and all things will come."*
ALMA KENNEDY GRAY WASHINGTON

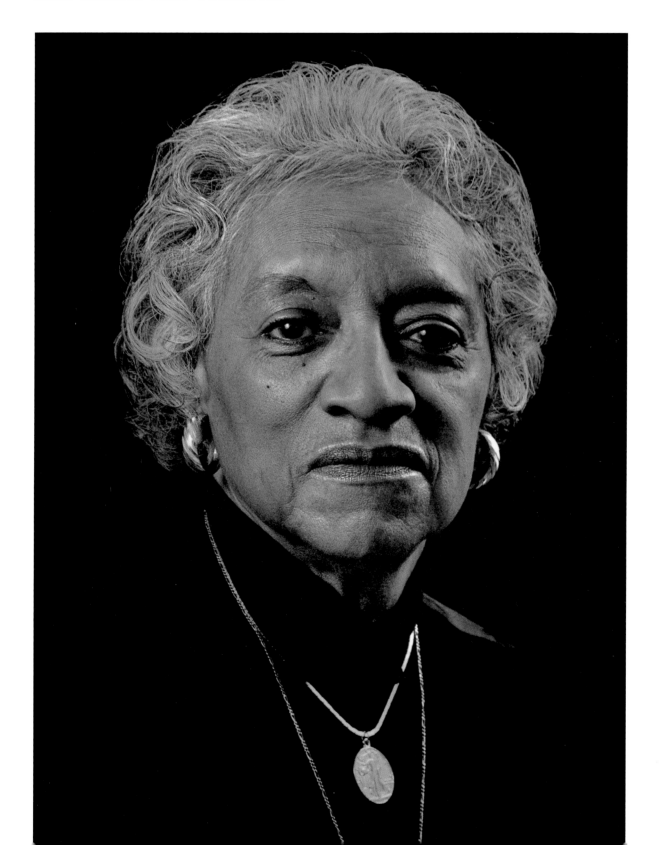

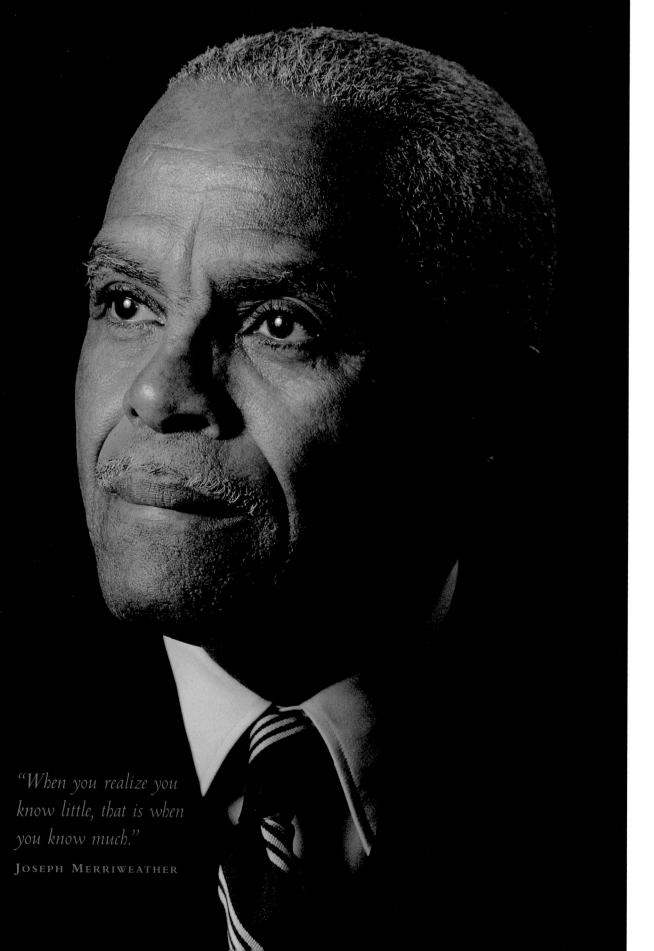

*"When you realize you know little, that is when you know much."*

JOSEPH MERRIWEATHER

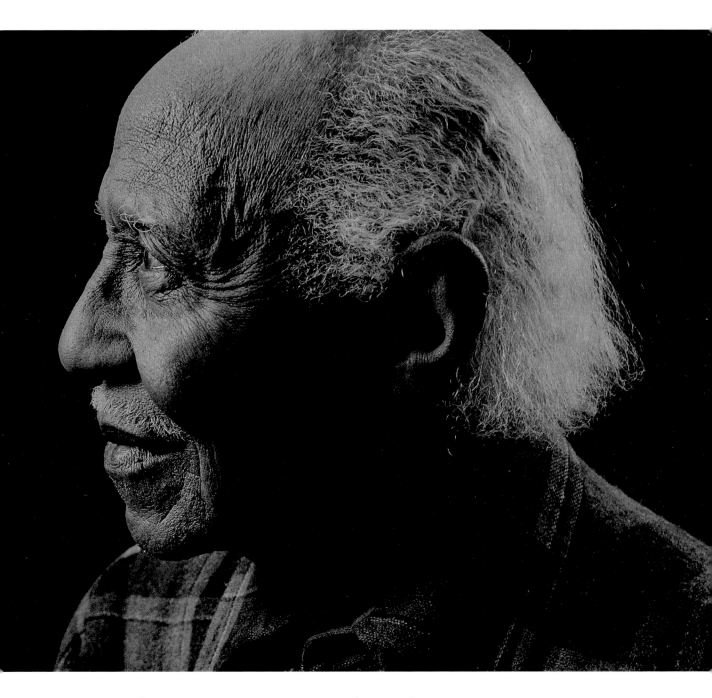

"*Everyone is a part of spiritual strength.*
*All of us have the power to have a realistic*
*spiritual force and the ability to call upon it.*"

ZEDFREDERICK ALSTON SR.

*"I believe in family. It's what everything is about in life—being able to get together, sit down and have a meal, and talk about old times and present-day happenings. I always feel good when my brothers and I get together."* JAMES A. PHILLIPS

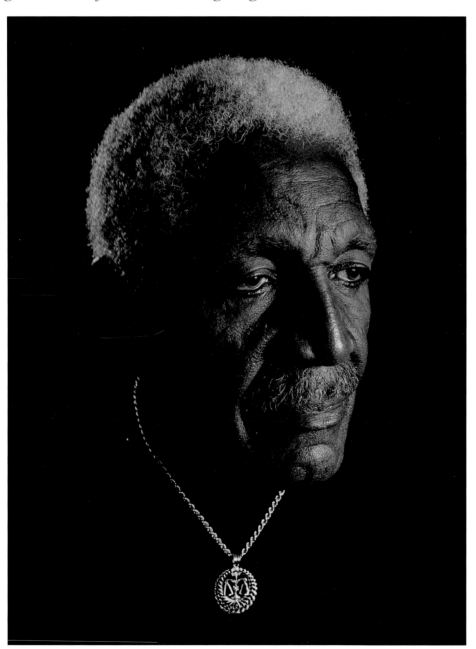

*"My aunt started each day giving thanks to God for another day, and I've learned to do the same. She pointed the way to gratitude for life and from gratitude to grace."* AGATHA FRANCES

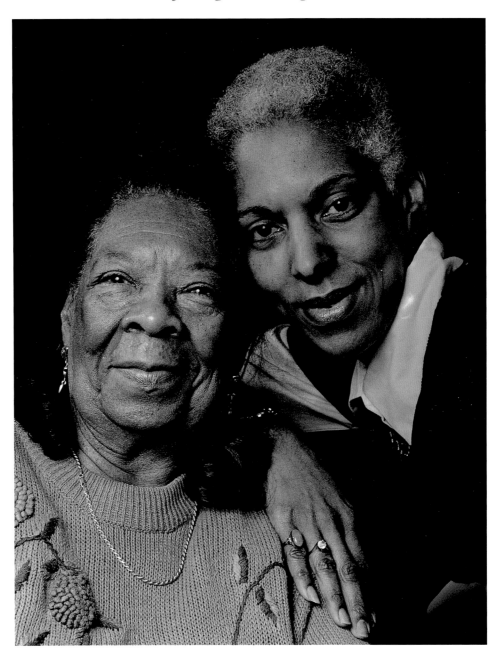

*"Most of the time, open your mouth only when it's necessary. What goes out cannot come back in."* VIOLA POWELL

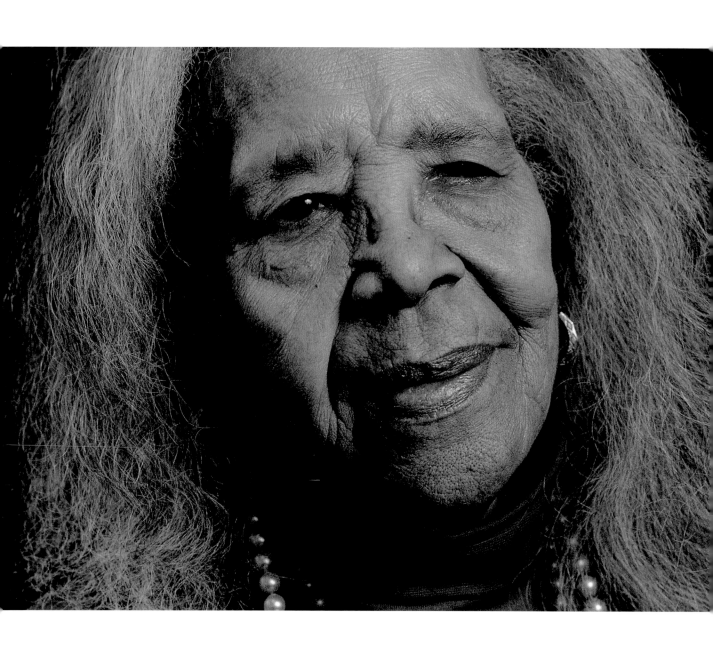

*"I've learned to put the past behind me and move forward."* ELEANOR JONES

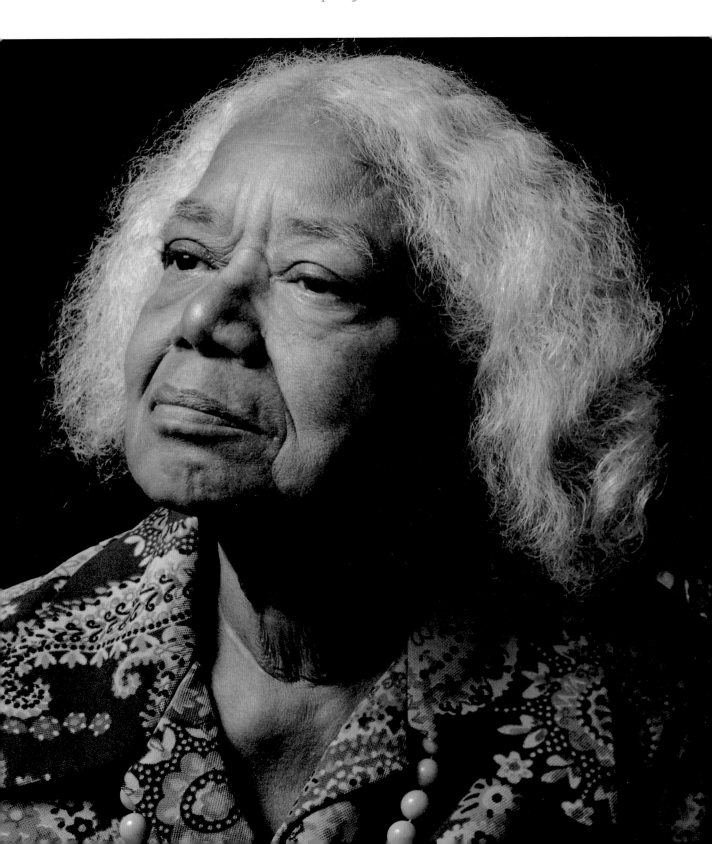

*"If you have kids, you have to know who their friends are. That's what I did. That's what my mother and father did."*

KEITH BUTLER

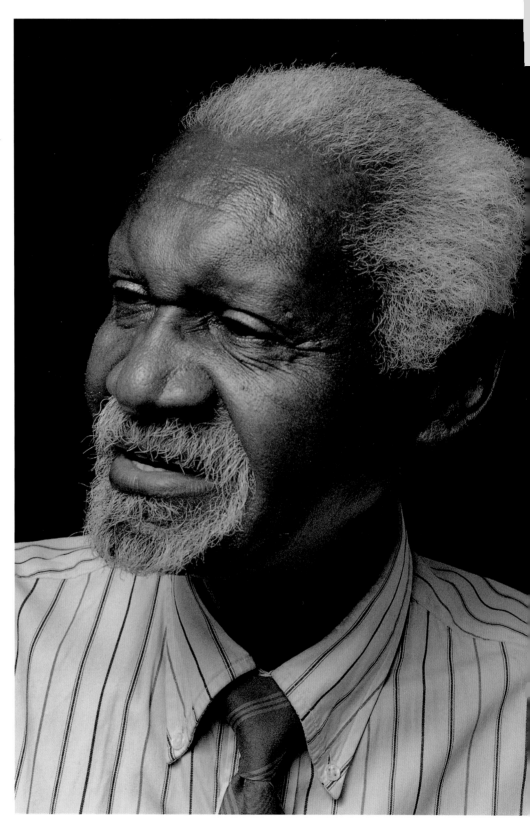

*"Find something to do. Don't just sit there and wait for the Lord to come and take you."*

Rosita E. Dalmida

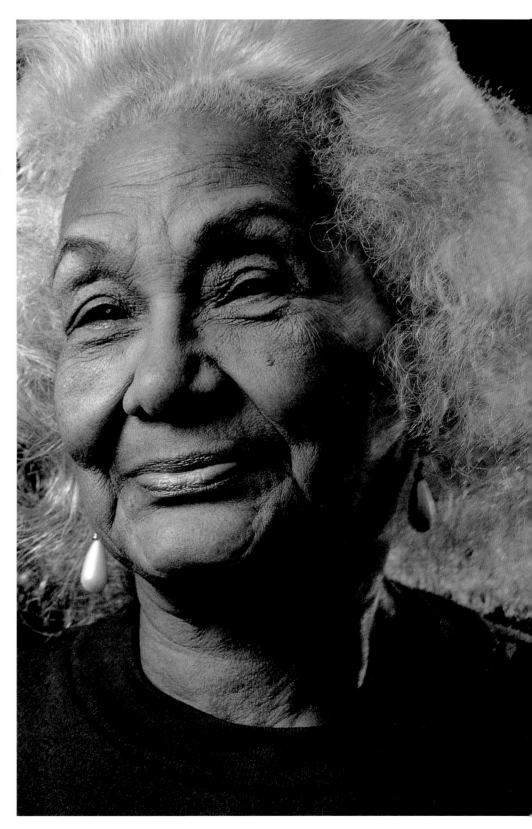

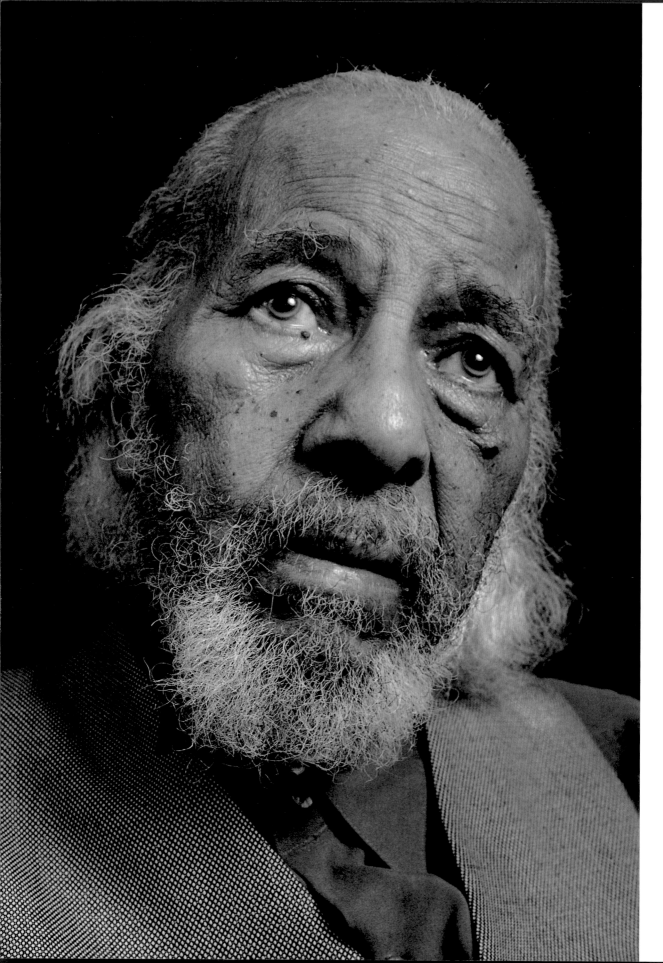

*"Whomever you know, know well; whatever you do, do well; whenever you speak, speak kindly; and give joy wherever you dwell."* SYDNEY WILLIAMS

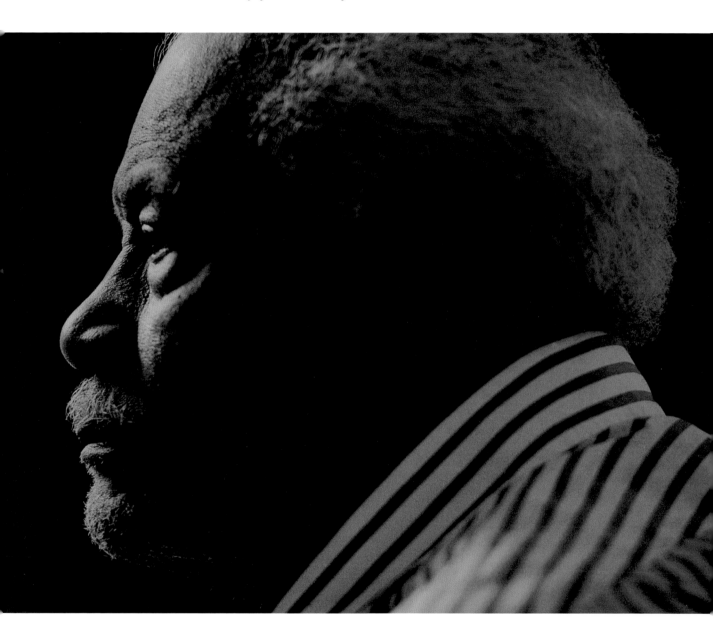

<     *"Some people tell me I work too hard, but how am I going to get tired of doing the things I enjoy?"*

   LUTHER WILLIAMS

*"With family and friends around me, I adjusted to being by myself."*

ALICIA JOHNSON

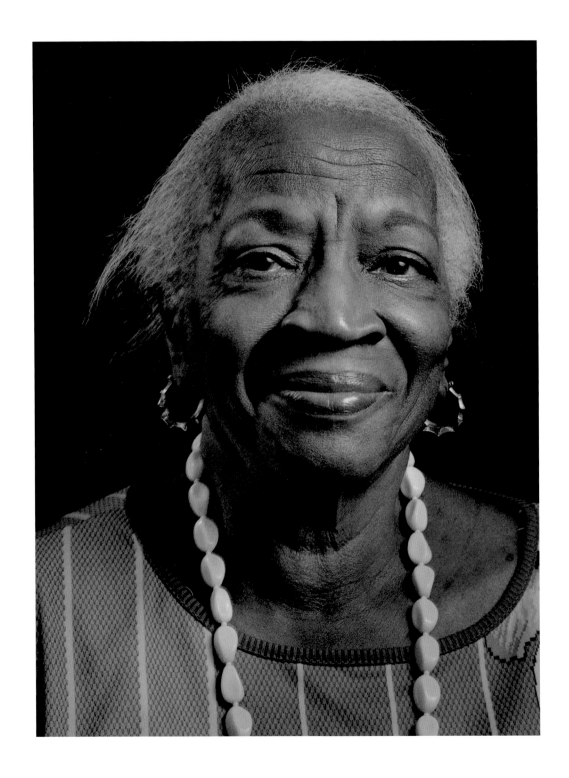

*"Family rituals are important. I always insisted on family meals—always had a family setting. During the summer we took the kids on vacation with us. Training and teaching must begin at home."*

FRED L. RUSSUM

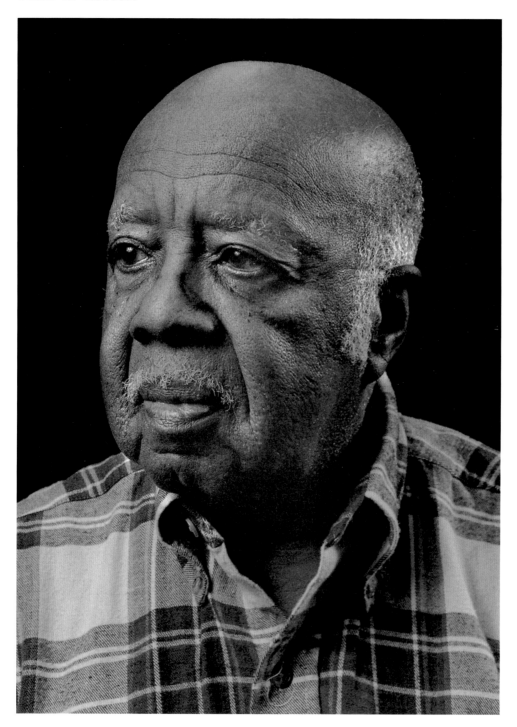

"To live and to die are the wages of life. Death is not an object or an end. I'm going to do whatever I can before it comes." HAROLD F. HAMILTON

UNTIL SUCH TIME

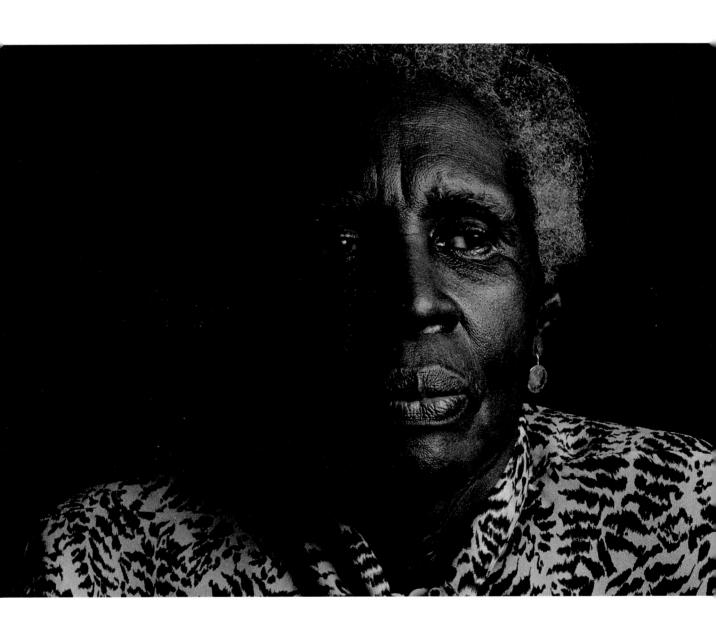

"*There's a lot of strength and solidarity in associations. We're too scattered today. There's strength in talking to each other. We need each other.*" LUCIA H. JACK

*"I never give up. I believe if you have something in your heart you really want to do, you can do it. I hear myself telling the kids that all the time."*

C. EVELYN EDMUND

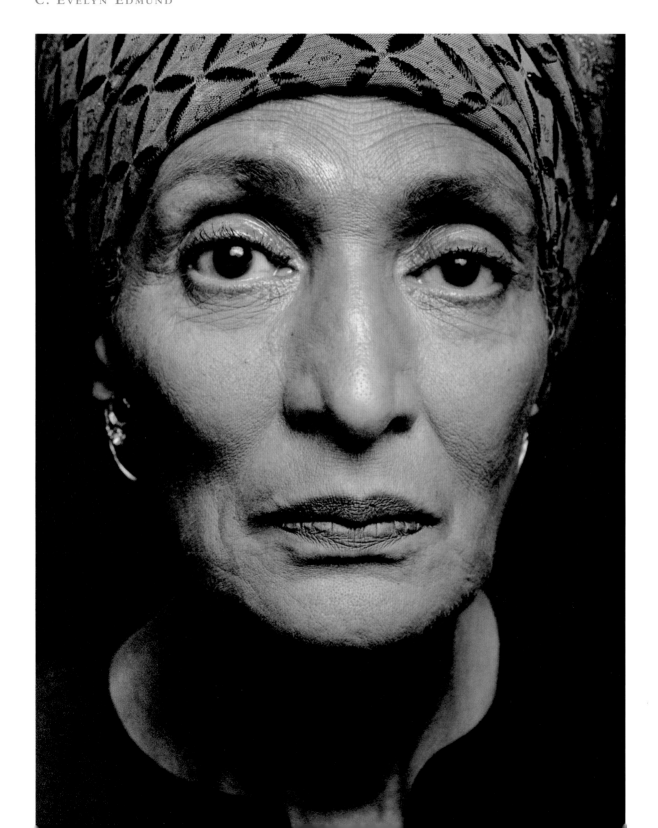

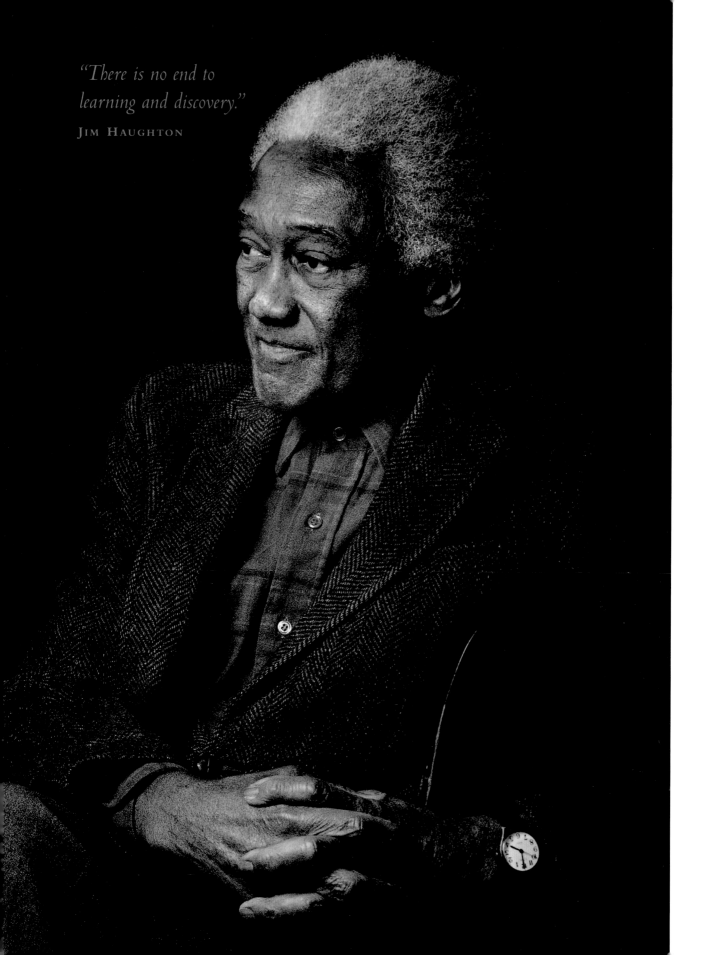

*"There is no end to
learning and discovery."*

JIM HAUGHTON

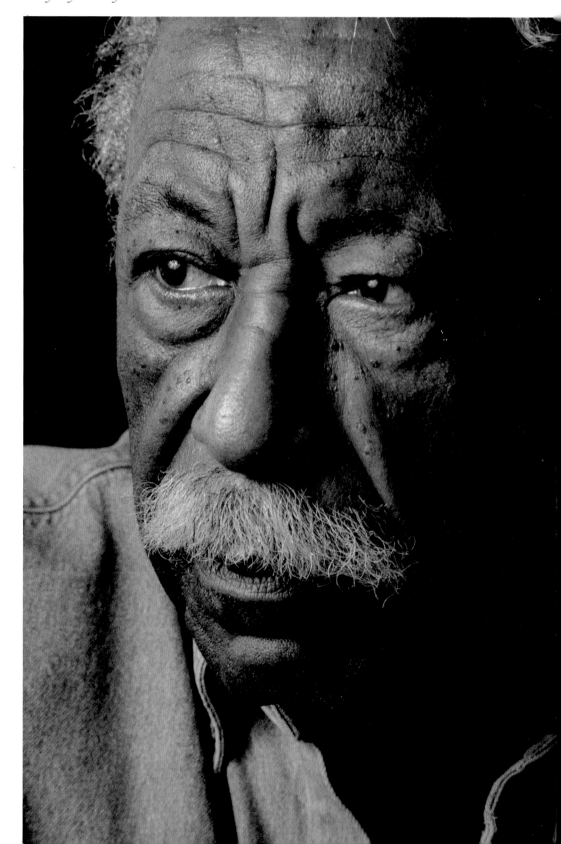

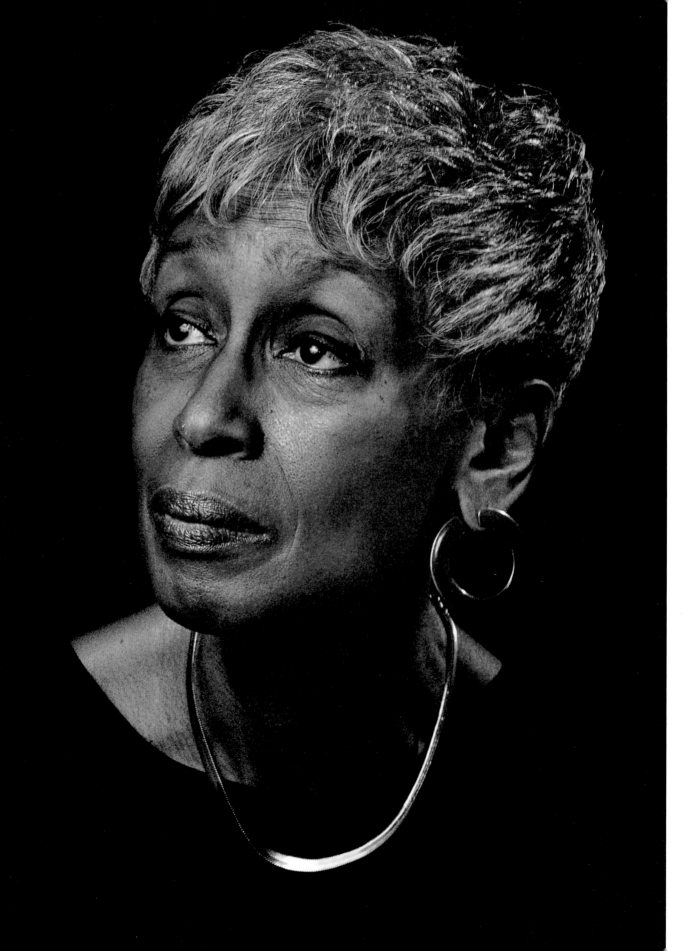

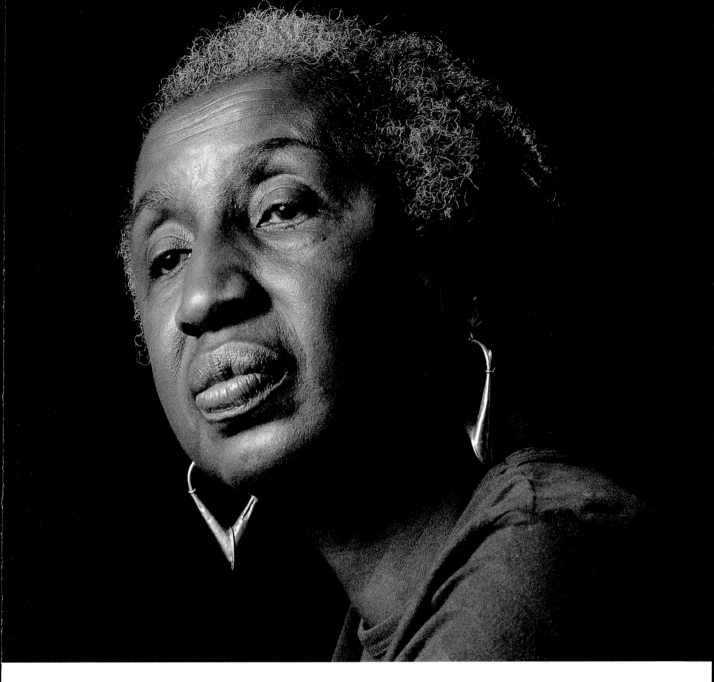

"*I keep challenging myself. When you open the door to knowledge, you can't close it again—it won't close—and you just keep searching for more and more light.*"

MIRIAM B. FRANCIS

< "*Being able to help people gives me a lot of joy, and that comes in various ways. Sometimes it comes in just sitting down and talking to people, and sometimes in pointing people in a direction where they can get the kind of help they need.*"

FREIDA BURGEE

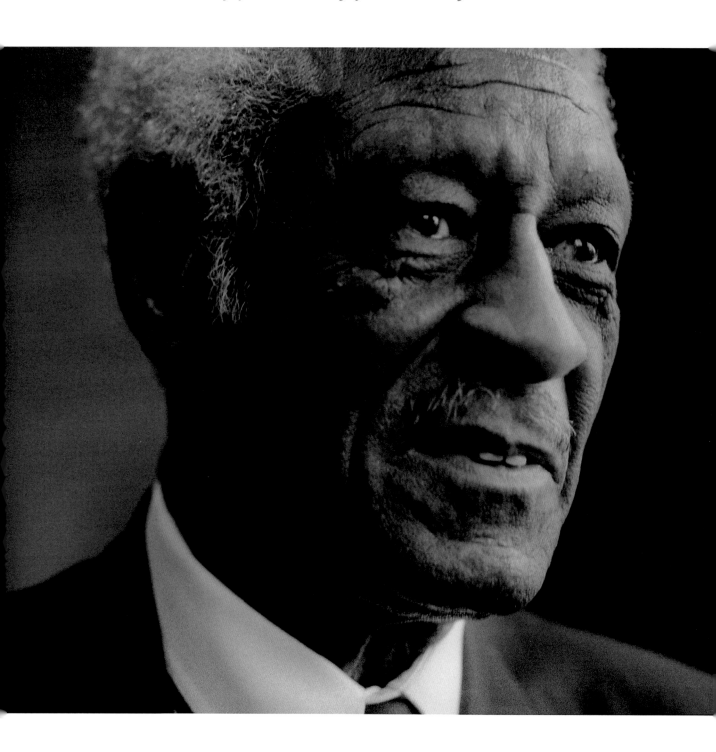

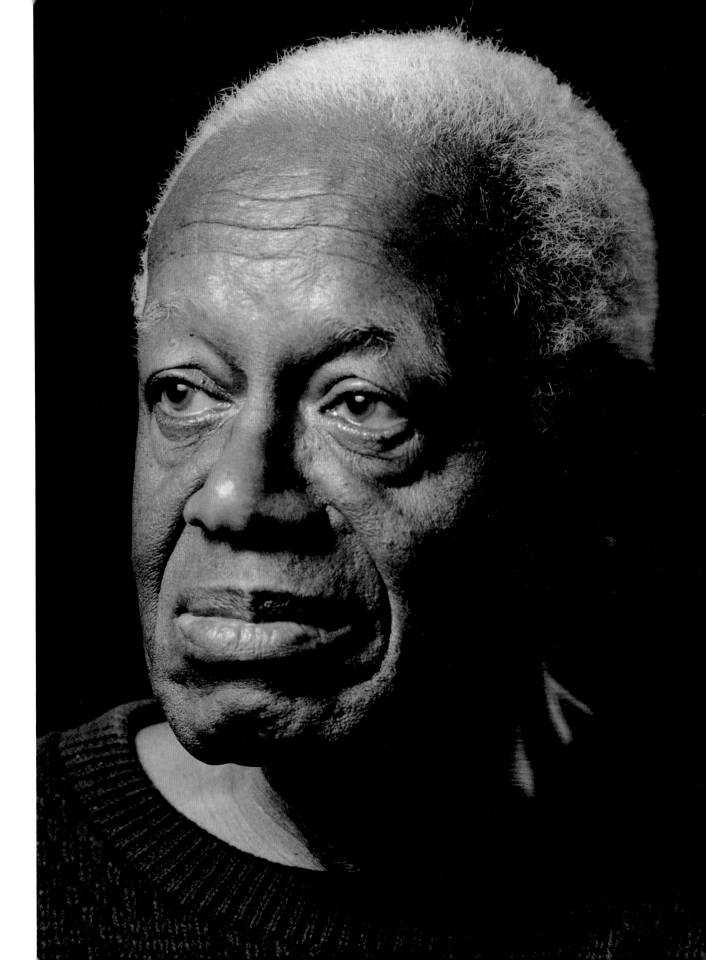

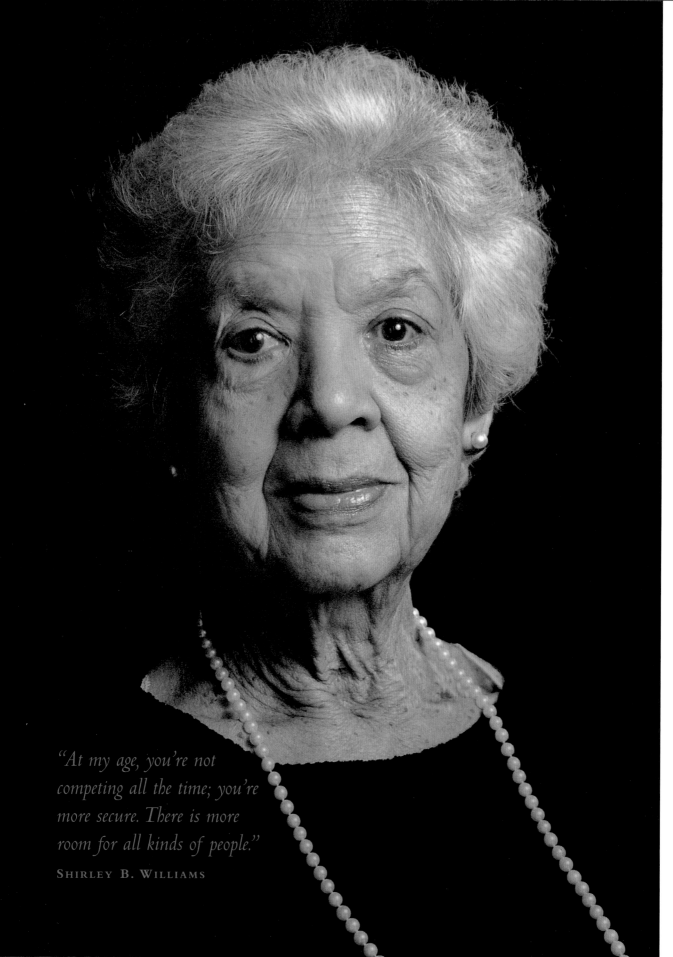

"At my age, you're not competing all the time; you're more secure. There is more room for all kinds of people."

SHIRLEY B. WILLIAMS

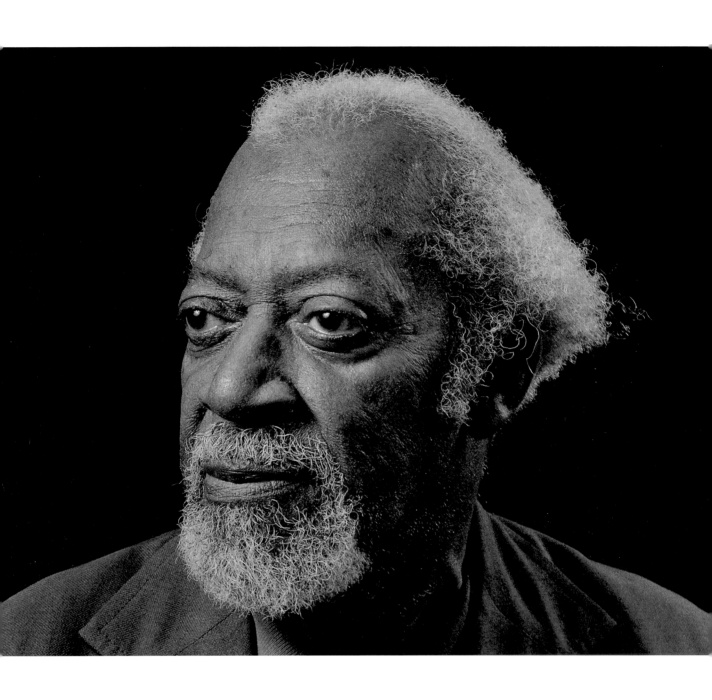

*"Playing the piano keeps me thinking. I'm always working on different arrangements."*

STANLEY WILLIS

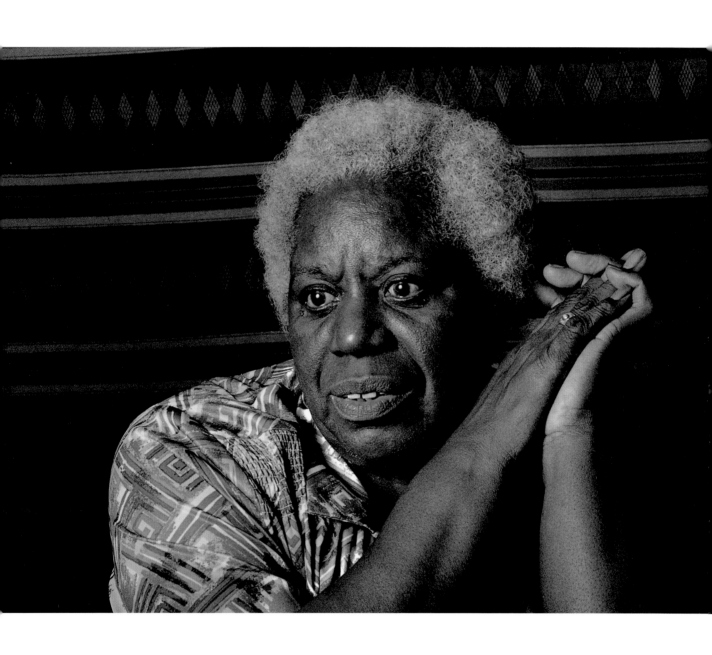

"*Get out of yourself. Do for others. Out of twenty-four hours in each day, you have to make it special. I program my day: some for others and some for me.*" RUTH A. GEORGE

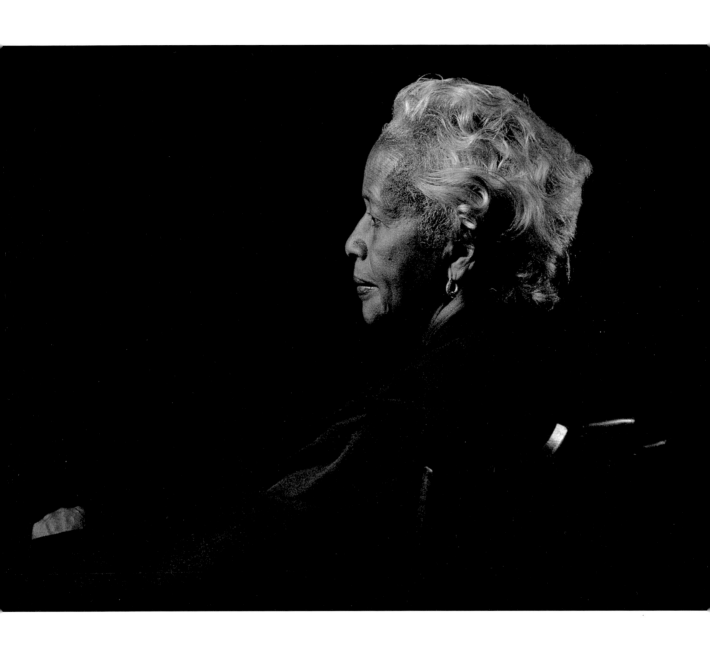

*"You don't know yourself until you see
yourself through the eyes of a child."*

Mavis Wilson Swire

*"There's room in the world for two ideas on almost anything. Who's right or who's wrong is hard to say."*

DORIS I. GUINIER

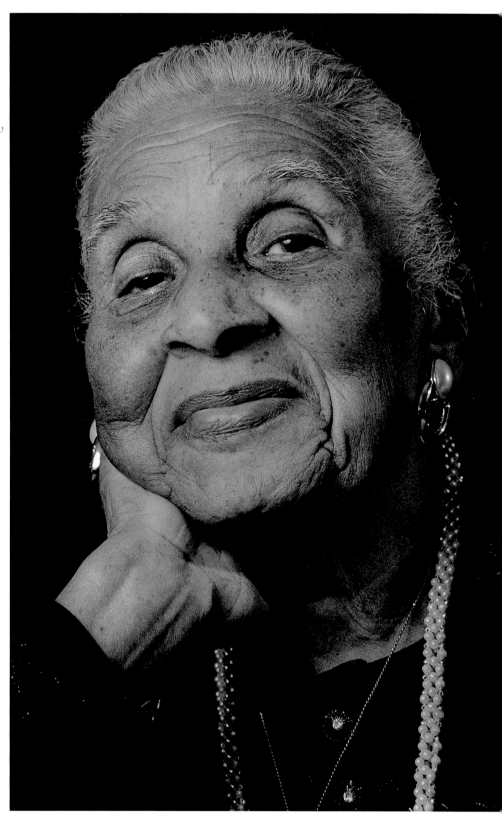

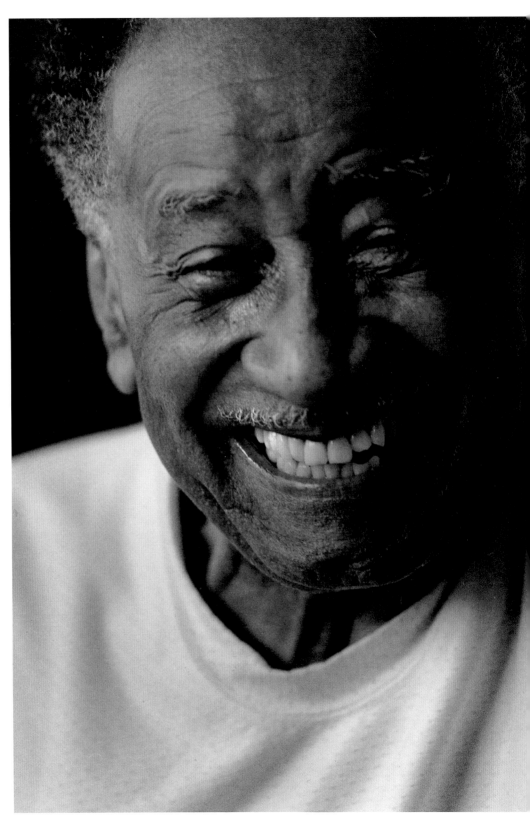

"Improvisation is it. You've got to be improvising all the time. Nothing is permanent. Tune in on Wall Street and it's a jam session. If you go there and play in one key, you'll go broke."

ALBERT MURRAY

*"I'm one of a group of seniors who work with junior high school students. Our work is the commingling of all that we've learned with what the students are learning and what they want to share. Young people have so much to offer."* SADIE WINSLOW

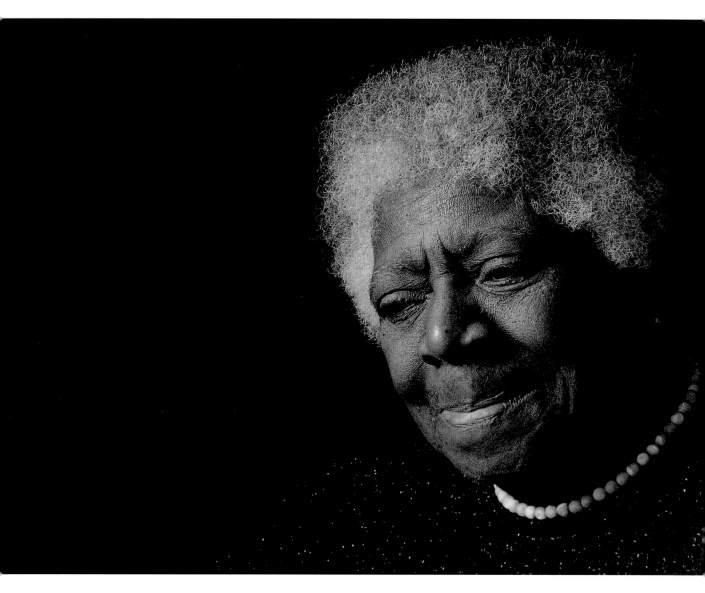

*"Companionship is key. It can make you live longer."*
EMELDA C. MILLS

*"Time is shortening up on us on a daily basis, and we don't want to waste a moment of it."* LA ROI MILLS

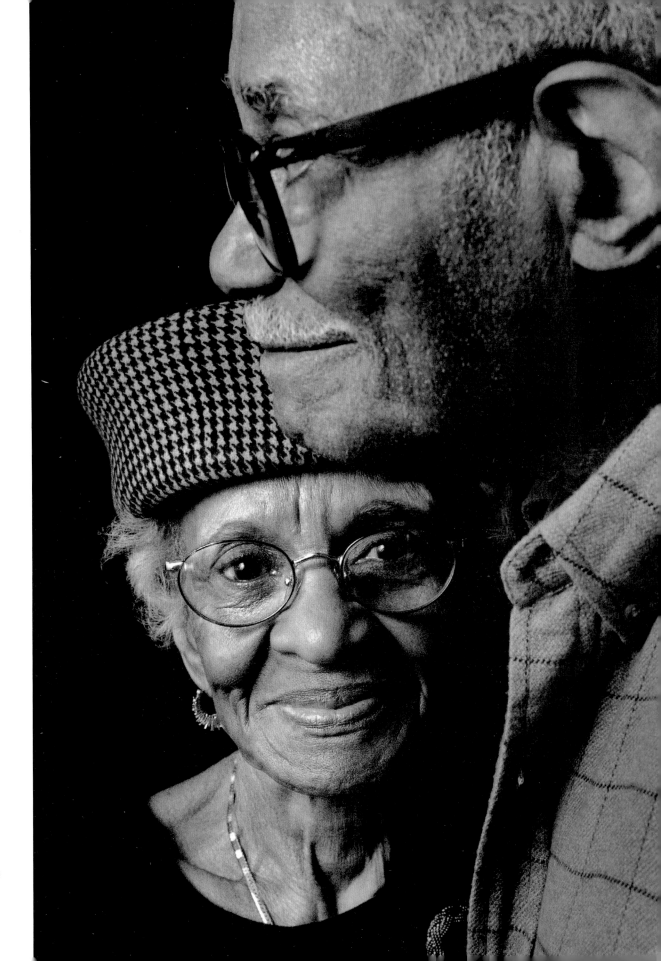

*"Politics determines the realities of what goes on. In a democracy, you must be a participant if you expect to achieve."* MILTON H. RICHARDSON

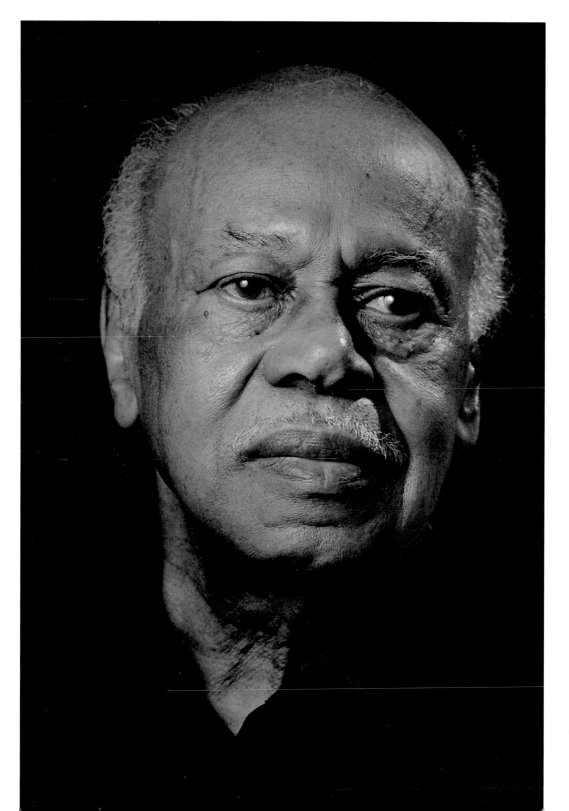

*"Write your problems down, then look at the list a year from now, and see how time has changed them."* ANTHONY PERKINS

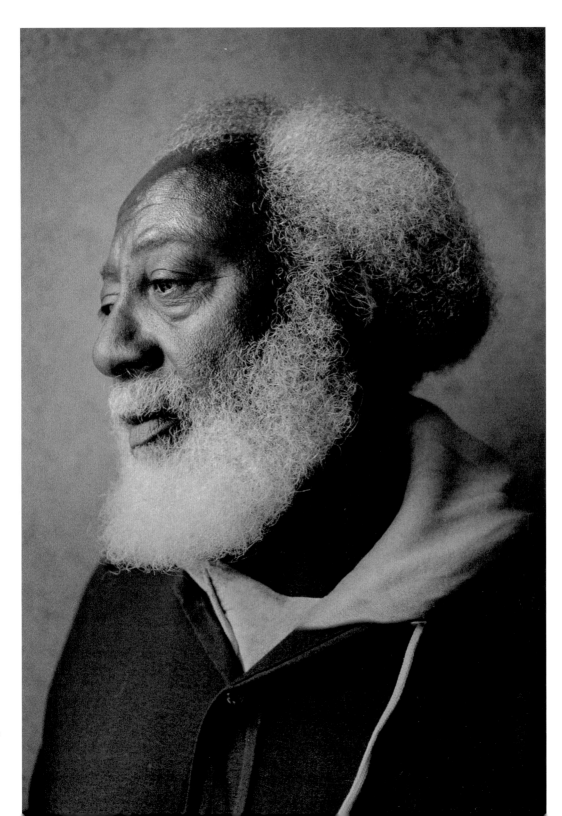

# Epilogue

Since birth is fatal, *Elder Grace* is about my past — and my future self.

In my youth, one of my greatest joys was being around my older, wise relatives. People of my grandparents' generation carried themselves with an elegance of grace and shared insights gained from years of living. Their conversations had the ring of philosophy, and what I can remember impresses me still. Often I see remnants of those personalities in the faces I photograph today.

*Elder Grace* also took me on a journey into my future — my own aging. Most of us have a fear of the natural process of growing old. None of us knows how we will fare, what loved ones will be with us, or who will leave us behind. In spite of all this, some of us miraculously blossom, seasoned by years of living. These are the faces that shine, etched and honed by life in all its complexity — these are the people, like the wise elders I grew up among, who have a saying, a thought, a wish, or advice for all who take the time to listen.

For those lucky ones, the future will make us elders, too. The path to an enlightened older age is not clearly marked and indeed is treacherous. I believe the eighty men and women whose interior portraits appear in this book are forging paths that offer inspiration — at whatever age we find them.

CHESTER HIGGINS JR.

# BIOGRAPHIES

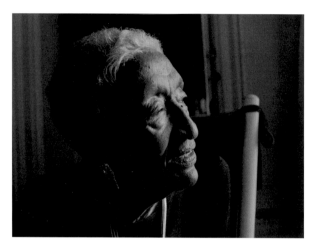

*In Their Hearts*

p. 14

**EVELYN CUNNINGHAM**

**WINTER 1916**

Journalist

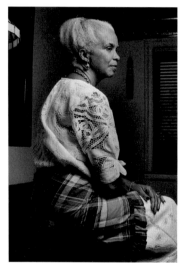

p. 15

**MARIE BROOKS**

**SPRING 1929**

Researcher of traditional dance and music and development of mind, body, and spirit for youth; founder of youth dance theater

*Four children and four grandchildren*

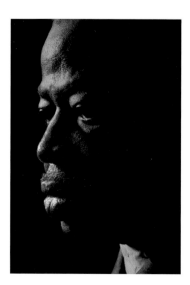

p. 16

**YOSEF BEN-JOCHANNAN**

**WINTER 1918**

Historian

*Seven children, fifteen grandchildren, twenty-five great-grandchildren, and one great-great-grandchild*

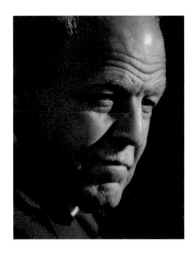

p. 17

**SAMUEL W. ALLEN**

**WINTER 1917**

Attorney; professor; writer

*One child*

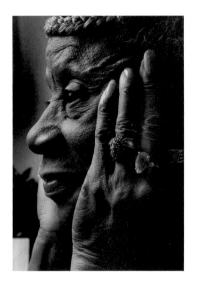

p. 18

**BERNICE NONA STAGGERS**

**FALL 1915**

Currency examiner; community volunteer

*Four children, eight grandchildren, and one great-grandchild*

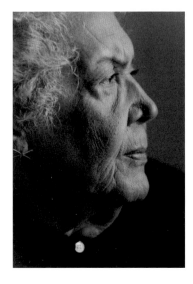

p. 19

**ELIZABETH CATLETT**

**SPRING 1915**

Sculptor

*Three children, eight grandchildren, and one great-grandchild*

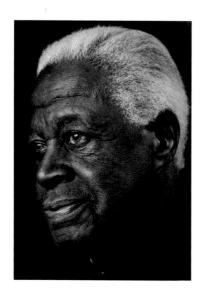

p. 20

**HAROLD F. HAMILTON**
**SUMMER 1918**

Attorney

*Three children, two grandchildren, and one great-grandchild*

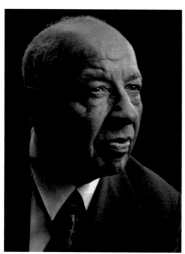

p. 21

**CHARLES MUSHAW**
**FALL 1921**

Corrections department officer; photographer

*One child*

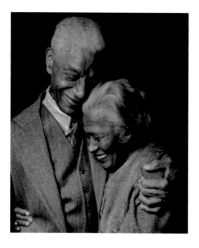

p. 22

**GEORGE CECIL WINSOR**
**WINTER 1914**

U.S. Postal Service employee; political activist

*Two children, five grandchildren, and four great-grandchildren*
(WITH HIS WIFE)

**LETTICE EDWARDS WINSOR**
**SPRING 1914**

Municipal supervising clerk

*Two children, five grandchildren, and four great-grandchildren* 106

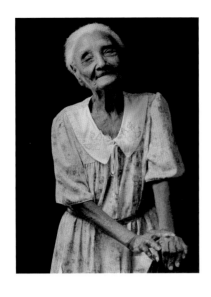

p. 23

**THERESA MATILDA HAMILTON**
**SPRING 1904**
Schoolteacher
*Three children*

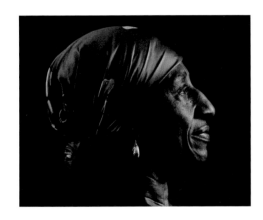

p. 24

**LOIS C. ROBINSON**
**FALL 1929**
Homemaker; certified nurse assistant
*Three children and two grandchildren*

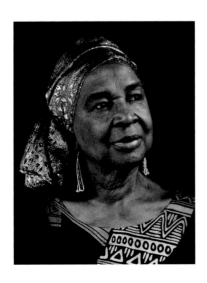

p. 25

**LOUISE MERIWETHER**
**SPRING 1923**
Writer

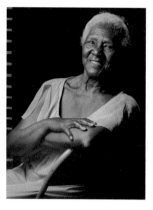

p. 26

**ELIZABETH P. JONES**

**WINTER 1908**

Domestic worker; singer

*Six children, two grandchildren, and fifteen great-grandchildren*

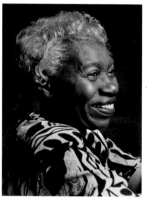

p. 27

**GLORIA HUNTER**

**SPRING 1921**

Secretary for school principal

*Three children and three grandchildren*

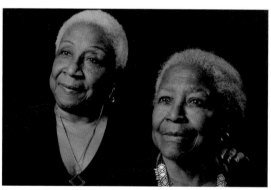

pp. 28–29

**PEARL I. ROMEO**

**FALL 1917**

Medical doctor; community medical consultant

*Two children*

(WITH HER SISTER)

**IANTHE DELILLE**

**SPRING 1915**

Board of education interpreter; mentor–tutor for neighborhood children

*Four children, seven grandchildren, and two great-grandchildren*

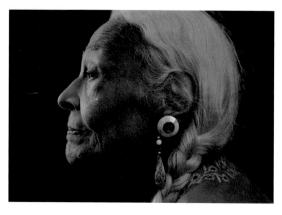

p. 30

**STEPHANIE BURNS**

**WINTER 1914**

Homemaker

*One child*

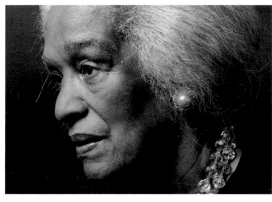

p. 31

**ARINA LATHAM-HOLMES**
**SPRING 1924**

Elementary education teacher and guidance counselor; substitute teacher; community activist
*Four children and ten grandchildren*

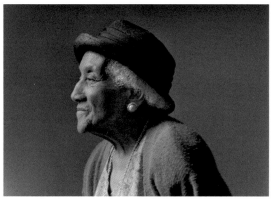

pp. 32–33

**MARIE PAYNE**
**SUMMER 1904**

Caregiver
*One child*

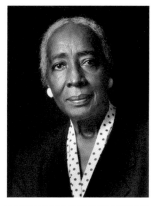

p. 34

**JUDY BLACKMAN**
**FALL 1924**

Federal Reserve System employee; community activist

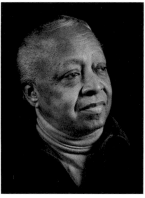

p. 35

**FREDDIE HAMILTON**
**FALL 1926**

Singer

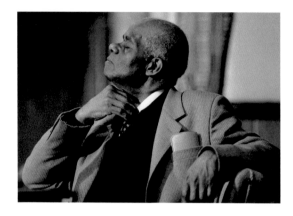

pp. 38–39
**JOHN HENRIK CLARKE**
**WINTER 1915**
Historian
*Two children*

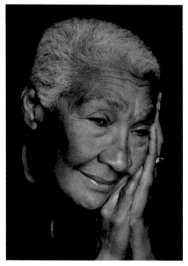

p. 40
**MARIA ORTIZ**
**WINTER 1930**
Seamstress
*Seven children, thirteen grandchildren, and five great-
grandchildren*

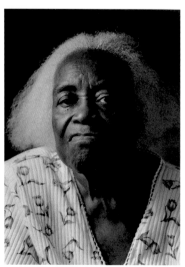

p. 41
**MARGARET INEZ WHITNEY**
**SUMMER 1909**
Businesswoman; caregiver
*Four children, two grandchildren, and two great-grand-
children*

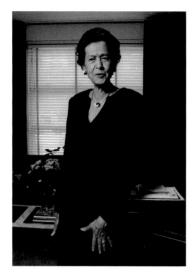

p. 42

**MONICA SMITH**

**FALL 1917**

Administrative assistant; classical singer; volunteer

*One child*

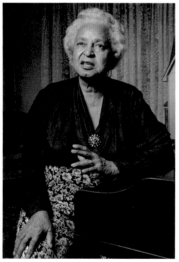

p. 43

**RITA HARRINGTON**

**SPRING 1925**

Retail worker; community activist

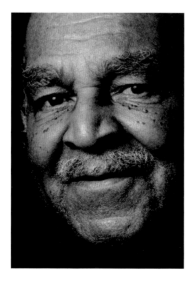

p. 44

**ALFRED DAVID HOLMES**

**WINTER 1912**

Chauffeur; community activist

*One child and four grandchildren*

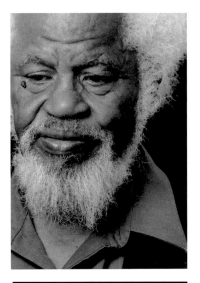

p. 45

**GILBERT HINES BANKS**
**SUMMER 1926**

Construction surveyor; labor organizer

*Two children*

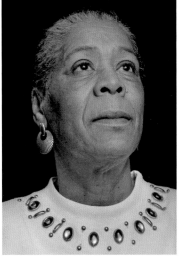

p. 46

**MARJORIE COULTHURST**
**FALL 1927**

Wife and mother

*Five children, six grandchildren, and six great-grandchildren*

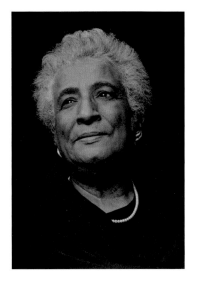

p. 47

**CONSTANCE BAKER MOTLEY**
**FALL 1921**

Wife and mother; state senator; borough president; civil rights lawyer; Senior U.S. District Judge

*One child and two grandchildren*

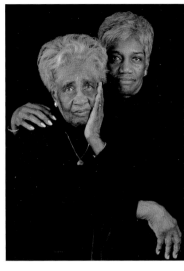

p. 48

**ANNIE MAE DENNIS**
**WINTER 1910**
Domestic worker
*Seven children, twenty-two grandchildren, and fourteen great-grandchildren*
(WITH HER DAUGHTER)

**MINNIE JONES**
**WINTER 1946**
U.S. Postal Service customer service supervisor
*Two children and four grandchildren*

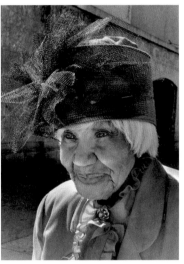

p. 49

**BEATRICE STROUD**
**SPRING 1917**
Teacher
*One child and five grandchildren*

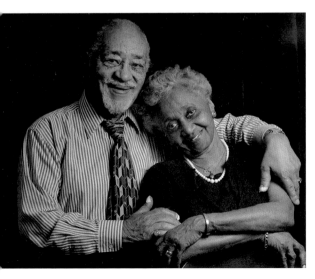

p. 50

**WILLIAM R. HUDGINS**
**SPRING 1907**
Founder of two banks and a mortgage company
*Two children, six grandchildren, and five great-grandchildren*
(WITH HIS WIFE)

**DOROTHY C. HUDGINS**
**WINTER 1921**
Nutritionist
*Two children, six grandchildren, and five great-grandchildren*

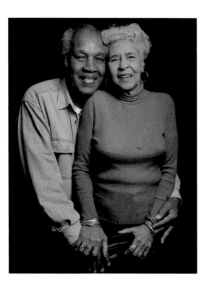

p. 51

**VALDORA JOHNSON**
**FALL 1914**
Homemaker; artist
*One child and two grandchildren*
(WITH HER COMPANION)

**ARTHUR BROWN**
**SUMMER 1924**
Municipal worker
*Four children, three grandchildren, and one great-grandchild*

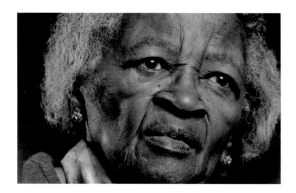

p. 52

**SUSIE CRAIG**
**SUMMER 1910**
Public schoolteacher; licensed practical nurse
*Two children, four grandchildren, and two great-grandchildren*

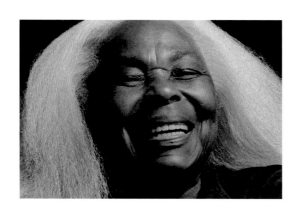

p. 53

**JOYCE MAYFIELD WATSON**
**WINTER 1920**
Dental technician
*Two children and two grandchildren*

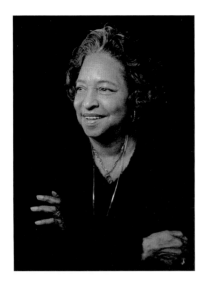

p. 54

**MYRTLE N. HAMILTON**

**SPRING 1924**

Business education teacher and counselor; entrepreneur

*Three children, two grandchildren, and one great-grandchild*

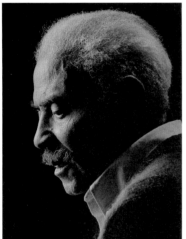

p. 55

**HARTWELL YEARGANS**

**FALL 1915**

Artist; art instructor

*Two children and one grandchild*

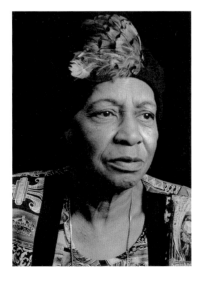

p. 56

**MARY CLARK**

**FALL 1924**

Home attendant; factory worker; community volunteer

*Two children, four grandchildren, and one great-grandchild*

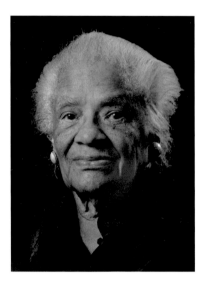

p. 57

**DAISY O'GILVIE**

**FALL 1902**

Hospital dietician; church volunteer

*Five children, six grandchildren, and one great-grandchild*

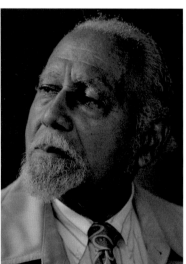

p. 58

**LEONARD NELSON NAPPER SR.**

**SUMMER 1917**

Social worker; singer; volunteer

*Two children and two grandchildren*

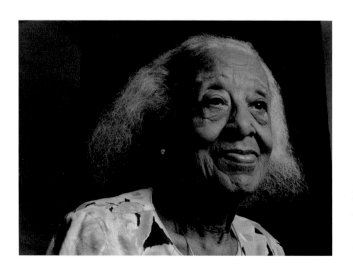

p. 59

**MAUDE CHRISTINA LANDIN**

**SPRING 1902**

Factory worker

# Divine Works in Progress

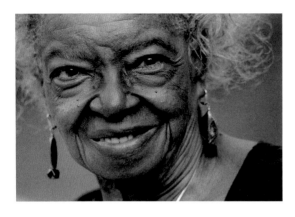

p. 62

**FAUSTINA P. ALBURY**

**SUMMER 1913**

Dress designer; civil servant

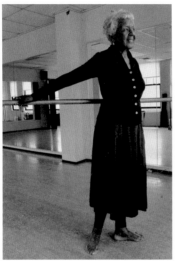

p. 63

**RUTH WILLIAMS**

**FALL 1916**

Early childhood educator; founder of dance studio for youth; school volunteer

*One child*

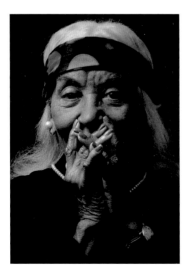

p. 64

**MURIEL HARRIS**

**SUMMER 1917**

Parks and recreation district manager; artist

*One child, two grandchildren, and one great-grandchild*

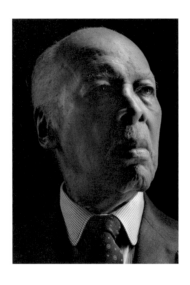

p. 65

**Marvin P. Smith**

**Winter 1910**

Photographer; tailor; veteran of World War II

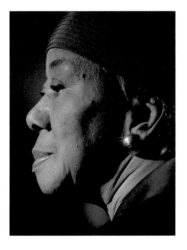

p. 66

**Florence T. Skinner**

**Summer 1918**

Corrections officer

*Two children, one grandchild, and one great-grandchild*

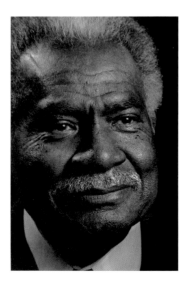

p. 67

**Ossie Davis**

**Winter 1917**

Writer; actor

*Three children and seven grandchildren*

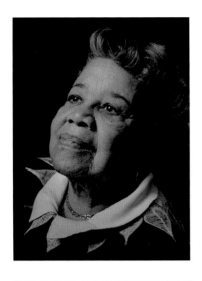

p. 68

**RHODA A. JONES HARRIS**
**WINTER 1913**

College administrative assistant; jewelry maker; inspirational entrepreneur

*One child*

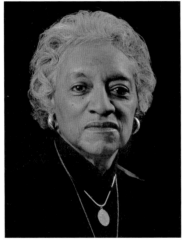

p. 69

**ALMA KENNEDY GRAY WASHINGTON**
**SUMMER 1926**

College administrator; community volunteer and activist

*Two children, four grandchildren, and five great-grandchildren*

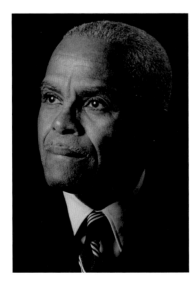

p. 70

**JOSEPH MERRIWEATHER**
**FALL 1928**

Executive; veteran of Korean War; church elder; volunteer for youth organizations

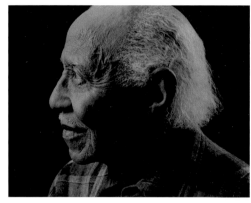

p. 71

**ZEDFREDERICK ALSTON SR.**

**FALL 1921**

U.S. Postal Service employee

*Four children, one grandchild, and one great-grandchild*

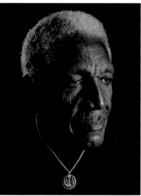

p. 72

**JAMES A. PHILLIPS**

**WINTER 1921**

Insurance agent

*One child*

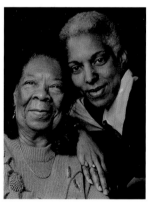

p. 73

**VIOLA POWELL**

**SPRING 1928**

Seamstress

*Two children, six grandchildren, and four great-grandchildren*

(WITH HER NIECE)

**AGATHA FRANCES**

**FALL 1950**

Attorney; entrepreneur; documentary producer

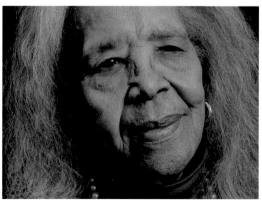

p. 74

**ELEANOR JONES**

**WINTER 1925**

Domestic worker

*Four children and two grandchildren*

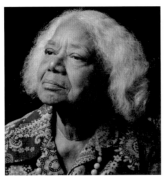

p. 75

**JOLENE FINNELL**

**FALL 1924**

Federal government employee

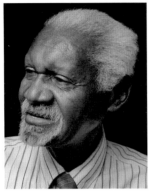

p. 76

**KEITH BUTLER**

**WINTER 1921**

U.S. Postal Service employee; supermarket manager; law firm assistant

*Two children, two grandchildren, and two great-grandchildren*

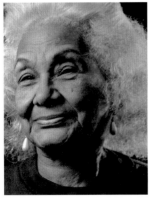

p. 77

**ROSITA E. DALMIDA**

**SPRING 1917**

Collator for book binder; church volunteer

*Two children, two grandchildren, and one great-grandchild*

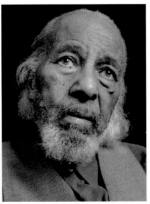

p. 78

**LUTHER WILLIAMS**

**SUMMER 1910**

Trolley car motorman; community activist

*Three children, twenty-five grandchildren, ten great-grand-children, and two great-great-grandchildren*

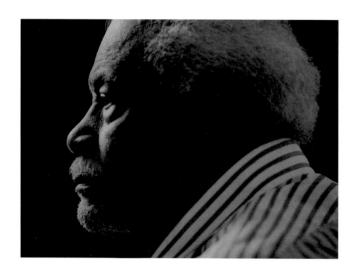

p. 79

**SYDNEY WILLIAMS**
**FALL 1916**

Hospital orderly; church elder

*One child, three grandchildren, and one great-grandchild*

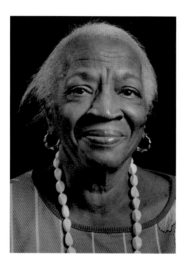

p. 80

**ALICIA JOHNSON**
**WINTER 1921**

Licensed practical nurse

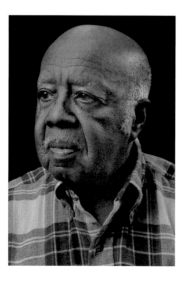

p. 81

**FRED L. RUSSUM**
**SUMMER 1919**

Housing authority employee

*Three children, five grandchildren, and three great-grandchildren*

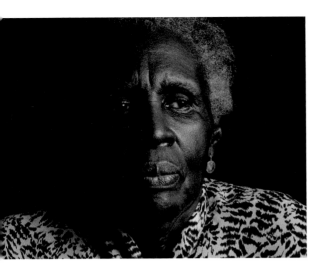

p. 84

**LUCIA H. JACK**

**SPRING 1925**

Librarian; community activist

*Three children and four grandchildren*

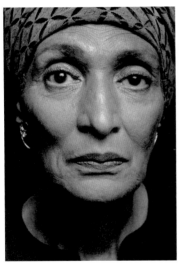

p. 85

**C. EVELYN EDMUND**

**SUMMER 1934**

Health care administration employee; church museum
director

*Three children and five grandchildren*

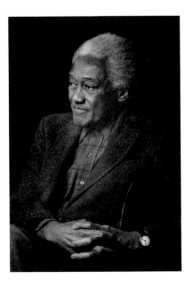

p. 86

**JIM HAUGHTON**

**FALL 1929**

Political human rights reformist

*Four children and seven grandchildren*

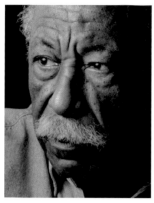

p. 87

**GORDON PARKS**

**FALL 1912**

Photographer; author; composer; motion picture director

*Four children, five grandchildren, and five great-grandchildren*

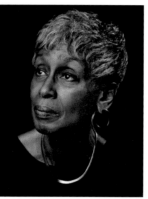

p. 88

**FREIDA BURGEE**

**SPRING 1932**

Social worker; political activist; church volunteer

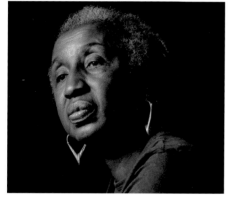

p. 89

**MIRIAM B. FRANCIS**

**FALL 1930**

Microbiology technologist; visual artist; community activist

*Two children and one grandchild*

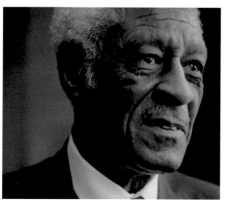

p. 90

**QUINCY GOLD**

**WINTER 1924**

Salesman; church elder; hospital volunteer

*Two children and one grandchild*

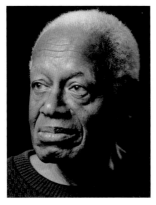

p. 91

**ERNEST CRICHLOW**

**SUMMER 1914**

Painter

*One child*

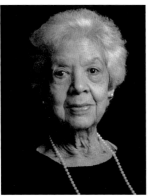

p. 92

**SHIRLEY B. WILLIAMS**

**WINTER 1923**

Educator; youth volunteer; foundation treasurer

*Two children and two grandchildren*

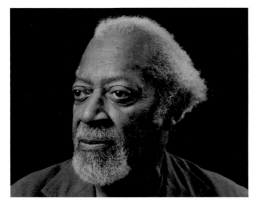

p. 93

**STANLEY WILLIS**

**SUMMER 1917**

Printing industry trimmer; jazz pianist and arranger

*Four children, six grandchildren, and six great-grandchildren*

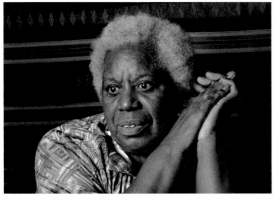

p. 94

**RUTH A. GEORGE**

**WINTER 1926**

Social Security supervisor; community activist

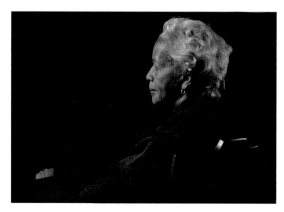

p. 95

**MAVIS WILSON SWIRE**

**FALL 1920**

Registered nurse; nursing educator; community
volunteer

*Two children and two grandchildren*

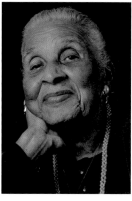

p. 96

**DORIS I. GUINIER**

**FALL 1908**

Teacher; guidance counselor

*One child and one grandchild*

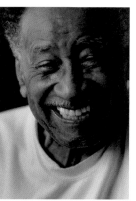

p. 97

**ALBERT MURRAY**

**SPRING 1916**

Writer; college professor; air force officer

*One child*

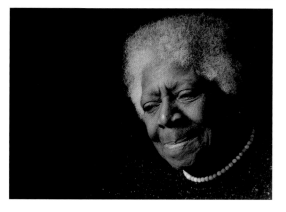

p. 98

**SADIE WINSLOW**

**SPRING 1916**

Preschool teacher; parent organizer; consultant;
school volunteer

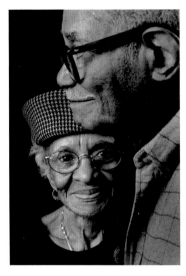

p. 99

**EMELDA C. MILLS**
**WINTER 1919**
Hospital secretary
*Two children and five grandchildren*
(WITH HER HUSBAND)

**LA ROI MILLS**
**SUMMER 1916**
Plant manager
*Two children and five grandchildren*

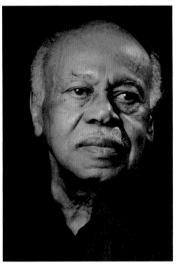

p. 100

**MILTON H. RICHARDSON**
**WINTER 1920**
Civil court judge; judicial hearing officer

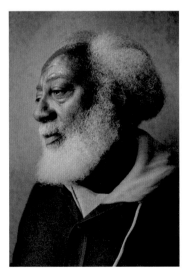

p. 101

**ANTHONY PERKINS**
**FALL 1924**
Construction worker; shipping clerk; railroad clerk;
volunteer
*Five children, five grandchildren, and one great-grandchild*

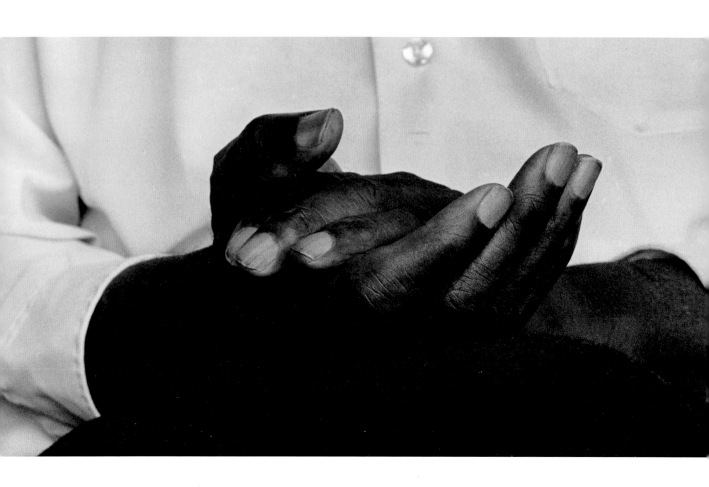